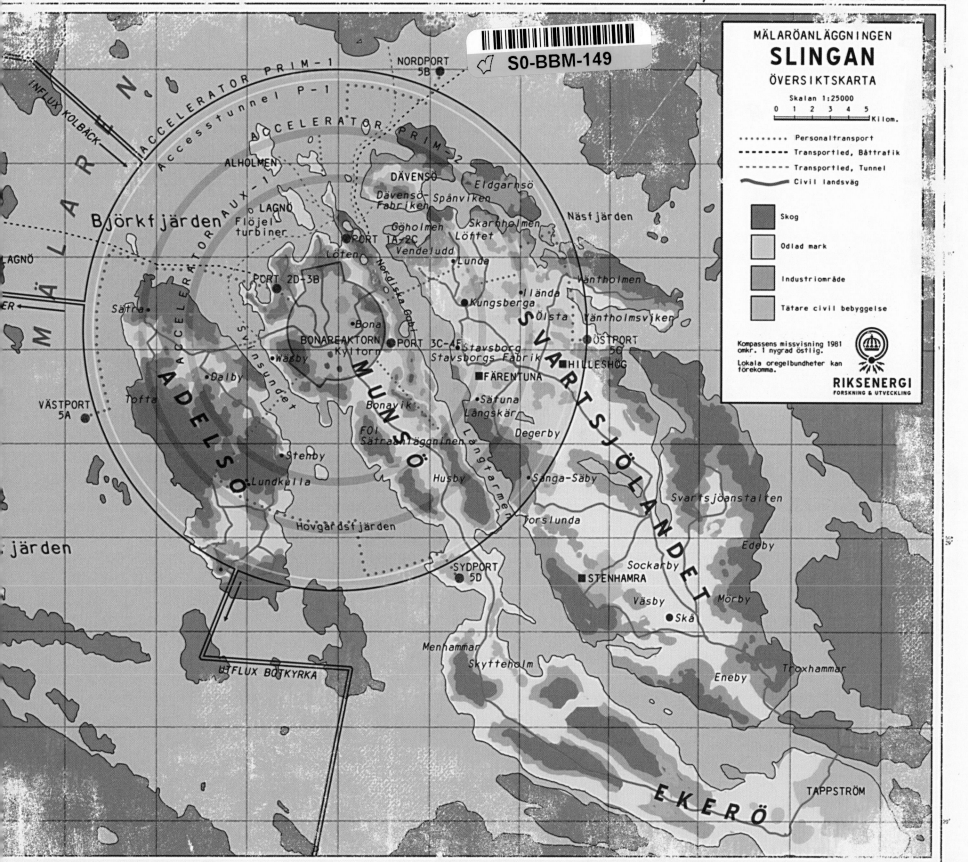

S0-BBM-149

MÄLARÖANLÄGGNINGEN
SLINGAN
ÖVERSIKTSKARTA

Skalan 1:25000

0 1 2 3 4 5
 Kilom.

············· Personaltransport
- - - - - - - Transportled, Båttrafik
– – – – – – Transportled, Tunnel
〜〜〜〜 Civil landsväg

Skog

Odlad mark

Industriområde

Tätare civil bebyggelse

Kompassens missvisning 1981
omkr. 1 nygrad östlig.

Lokala oregelbundheter kan
förekomma.

RIKSENERGI
FORSKNING & UTVECKLING

INFLUX KOLBÄCK
ACCELERATOR PRIM-1
Accesstunnel P-1
NORDPORT 5B
ACCELERATOR PRIM-2
ALHOLMEN
Björkfjärden
ACCELERATOR AUX-1
LAGNÖ
Flöjelturbiner
DÄVENSÖ
Dävensö-Fabriken
Spånviken
Eldgarhsö
Skarnholmen
Näsfjärden
Göholmen
Löftet
PORT 1A-2C
Vendeludd
Löten
Lunda
MÄLAREN
LAGNÖ
PORT 2D-3B
Nordiska Gatt
Vantholmen
Ilända
Kungsberga
Sätra
Bona
Ölsta
Vantholmsviken
BONAREAKTORN
Kyltorn
PORT 3C-4E
Stavsborg
ÖSTPORT 5C
Wäsby
Stavsborgs Fabrik
HILLESHÖG
VÄSTPORT 5A
Dalby
FÄRENTUNA
Tofta
Bonavik
Säfuna
SVARTSJÖLANDET
FOI Sätraanläggningen
Längskär
Degerby
Stenby
Husby
Sänga-Säby
Svartsjöanstalten
Lundkulla
Långtarmen
Forslunda
Hovgårdsfjärden
Edeby
Sockarby
SYDPORT 5D
STENHAMRA
Mörby
Väsby
Skå
UTFLUX BOTKYRKA
Menhammar
Skytteholm
Eneby
Troxhammar
järden
EKERÖ
TAPPSTRÖM

Rikskartor Stockholm 1981 Ej godkänd ur sekretesssynpunkt för spridning.
Statens lantmäteriverk 1981-04-27

130930

THINGS FROM THE FLOOD

Simon Stålenhag

Skybound Books / Gallery Books

New York • London • Toronto • Sydney • New Delhi

Dark pictures on the water, they have been hung away.

Like toys from our childhood that have grown to giants
and accuse us
of what we never became.

Tomas Tranströmer, SYROS

Sweden was leaving the era of big government projects. The decaying facilities and machines had been taken over by new developers who welded doors shut and wrapped machines in plastic, and who wanted to exploit the land for new uses. Radio towers rose above the woods behind the houses and, in the glades, humming new data centers melted ice and snow. Satellite dishes grew from the house walls and unfamiliar electrical sockets appeared inside. The children of the community gathered in front of home computers or TV sets (which suddenly showed cartoons at noon).

Somewhere out there beyond the cordons, beyond the fields and marshes, abandoned machines roamed like stray dogs. They wandered about impatiently, restless in the new wind sweeping through the country. They smelled something in the air, something unfamiliar.

Perhaps, if we had listened closely, we would also have heard it. We may have heard the sound rising from the forgotten and sealed caverns in the depths: the muffled pounding from something trying to get out.

PREFACE

My previous book, *Tales from the Loop*, told the tale of what it was like grow-ing up in the land of the Loop at the end of the Riksenergi era. The book covered the years from the early '80s until the decommissioning of the Loop in the fall of 1994, when Riksenergi was replaced with the privately owned Krafta corporation. But the story of the Loop did not end there. As I was working on the previous book, I already knew that the years from 1995 to 1999, and the strange events that followed the decommissioning of the Loop, would require a volume of their own.

Much has been written about the Mälarö leak and the subsequent Krafta scandal. During the last three years of the last millennium, it was a daily feature in the newspapers. My goal with this book is not to explain the events or contribute to the speculations and conspiracy theories that have surfaced throughout the years. Instead, just like in *Tales from the Loop*, I wish to describe my own memories of growing up on the outskirts of these events.

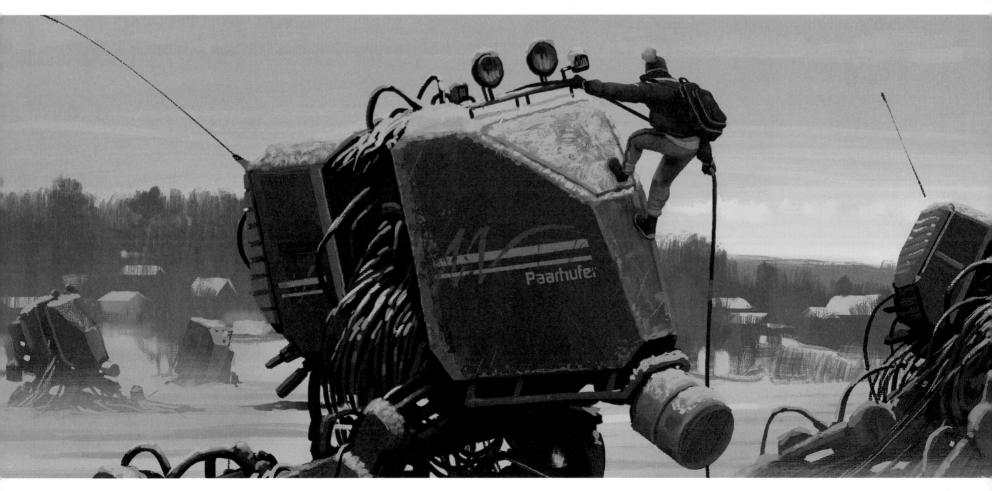

This book chronicles events that took place in the late 1990s. Since then, a number of revolutionary changes have come to pass that the history books clearly define as marking the end of one epoch and the beginning of another. The most dramatic was the sudden pole shift in the winter of 2001, which immediately crippled the magnetrine trade routes of the entire northern hemisphere and created the world-spanning ship graveyard known today as the Death Belt. The Mälarö leak and the subsequent dismantling of the Loop are, at least as far as Sweden's history is concerned, other such events that clearly mark the end of an era.

In everyday life, our surroundings only shifted slowly and subtly, such as altered designs of door handles and alarm switches, a soft color change in the glow of streetlights and lightbulbs, or a new font on the signs in the subway; likewise, bathrooms have been renovated, floorboards have been torn up, and kitchen cabinets have been repainted. Each is a minor change, but often, when looking back at them all together, they are as glaringly obvious as a sudden industrial collapse.

Change is the dynamo that slowly but inevitably drives our society forward, while past days are clouded more and more in mystery and myth. The dynamo only spins one way—there are no return tickets to the land disappearing in the mists behind us. The only passage between our world and the past lies buried deep in our own subconscious, somewhere in the blurred borderlands between our imagination and our memories, and that is where I hope to bring you now.

Darkness is falling outside my window, and out there in the dusk is the same landscape that was ravaged by the flood 21 years ago. In the twilight hours, it is hard to discern the details marking the passage of two decades. It is hard to separate memory from reality; my mind fills out all the blurry sections. At dusk, the field looks like an ice-covered lake. You could almost believe that the flood is back.

Simon Stålenhag, Kungsberga, February 2016

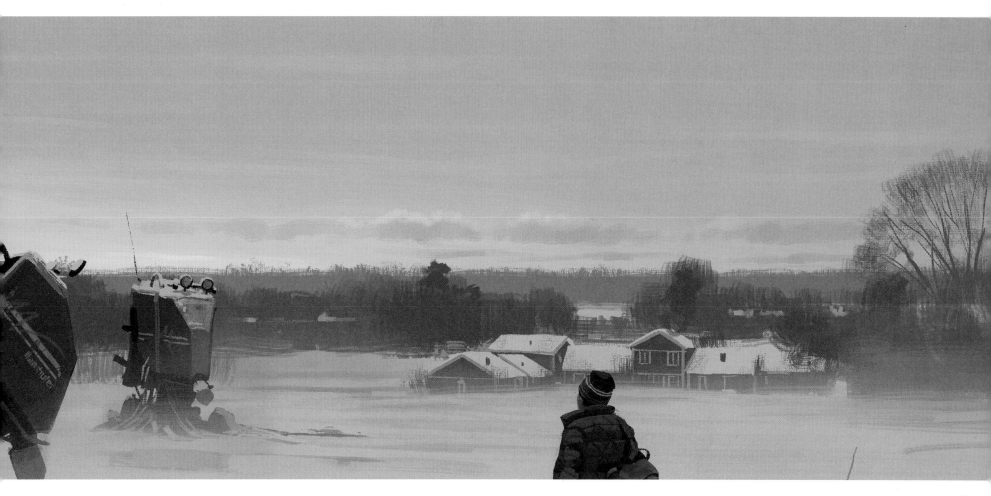

DARK STAINS

Busy as they were, wrapping presents and composing clever Christmas rhymes, none of the inhabitants of Mälaröarna noticed the dark stains in the snow behind Färentuna church. Nor did they see how they grew bigger and bigger after the second Sunday of Advent. And no one had reacted to the strange sounds and rank smells rising from drains and water faucets during the entire month of December, nor noticed how the Field Hat in Sätuna had been encased in a strange sculpture of brown ice since before Christmas.

But then Christmas Eve came around. In the early morning hours, it became clear to most of the inhabitants of northern Färingsö that Christmas of 1994 would go down in history for very different reasons than the Christmas rhymes. Most households woke up to the fact that their basements were being flooded by brown, ice-cold water.

BODIES OF WATER

It was clear that it was a leak from the innards of the Loop. It could not be rainwater: winter had come in early December and the ground was already frozen. It was as if the enormous underground facility had been flooded completely—every tunnel and chamber, and every tiny opening and duct leading from the Loop was leaking water.

Thinking back to that day, I mostly remember my own elation about what had happened. I thought the whole thing was awesome and I ran around the house, taking in every single detail of the mayhem. I was most interested in the basement stairs that disappeared down into a luminescent, deep sea world, lit by the plastic string of lights we had wrapped around the banister the previous day—lights that had miraculously avoided shorting out. In the depths of the water in the basement, half-dissolved paper and newspapers floated, as if gravity had been suspended.

Mom stood in the hallway in her coat and boots, with the phone wedged in between her ear and shoulder, screaming at someone from emergency services while at the same time stuffing clothes into a bag. The day only got better when the fire brigade's corsair ship finally landed in our backyard, and firefighters stomped in wearing boots and gas masks, and carrying axes.

If I had known that it would be three years before I saw my room again, I would probably not have felt that excited tingle when the ship's diesel engines lifted us above the water-soaked landscape.

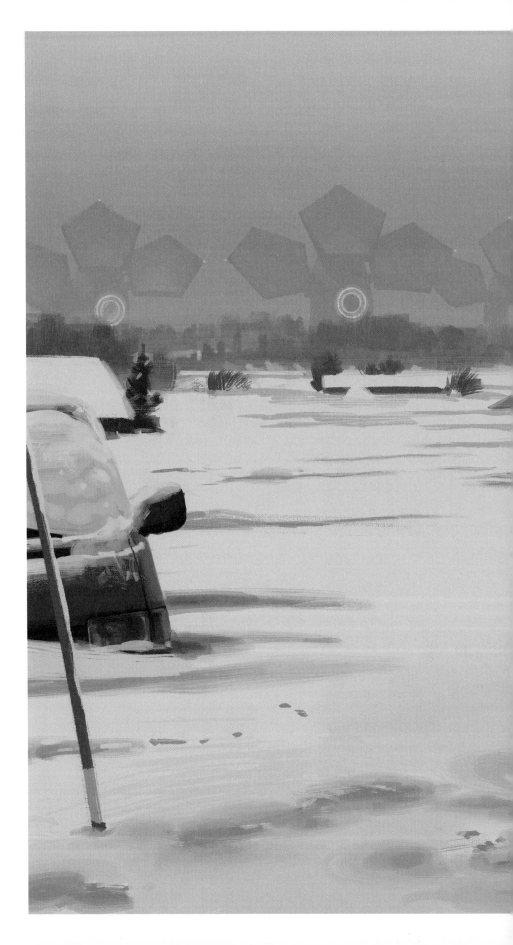

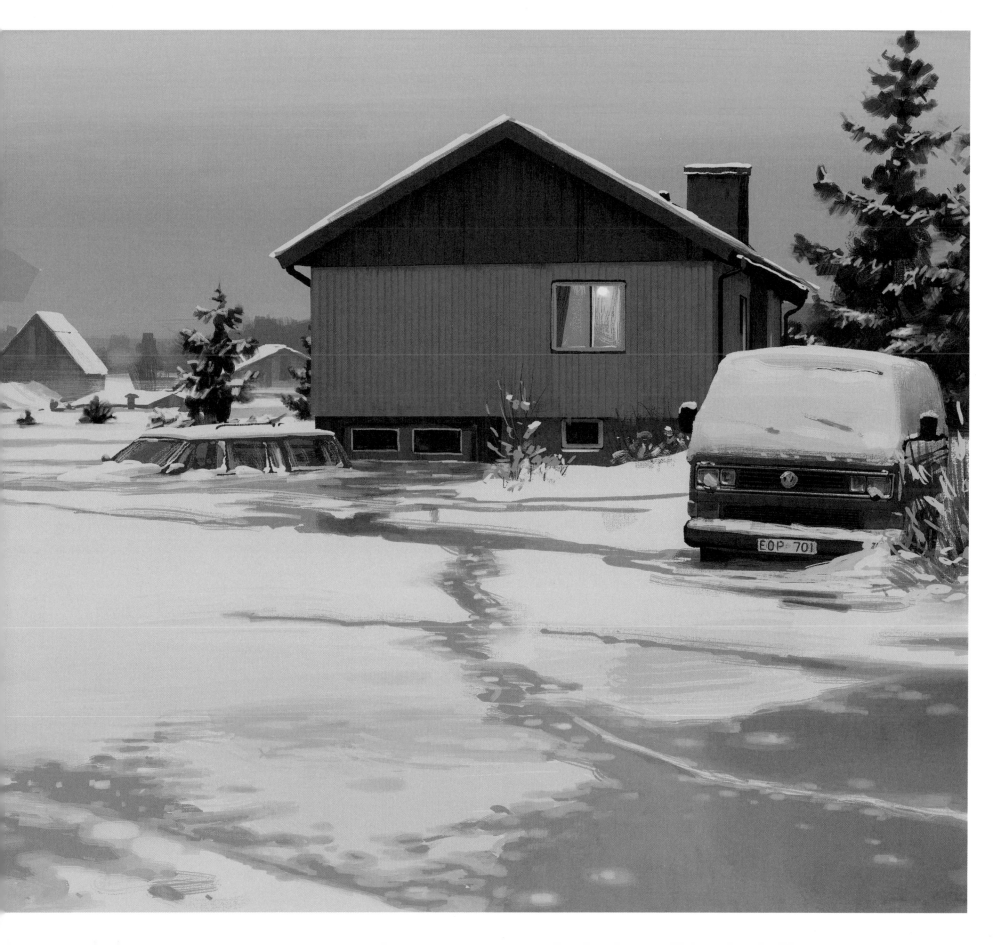

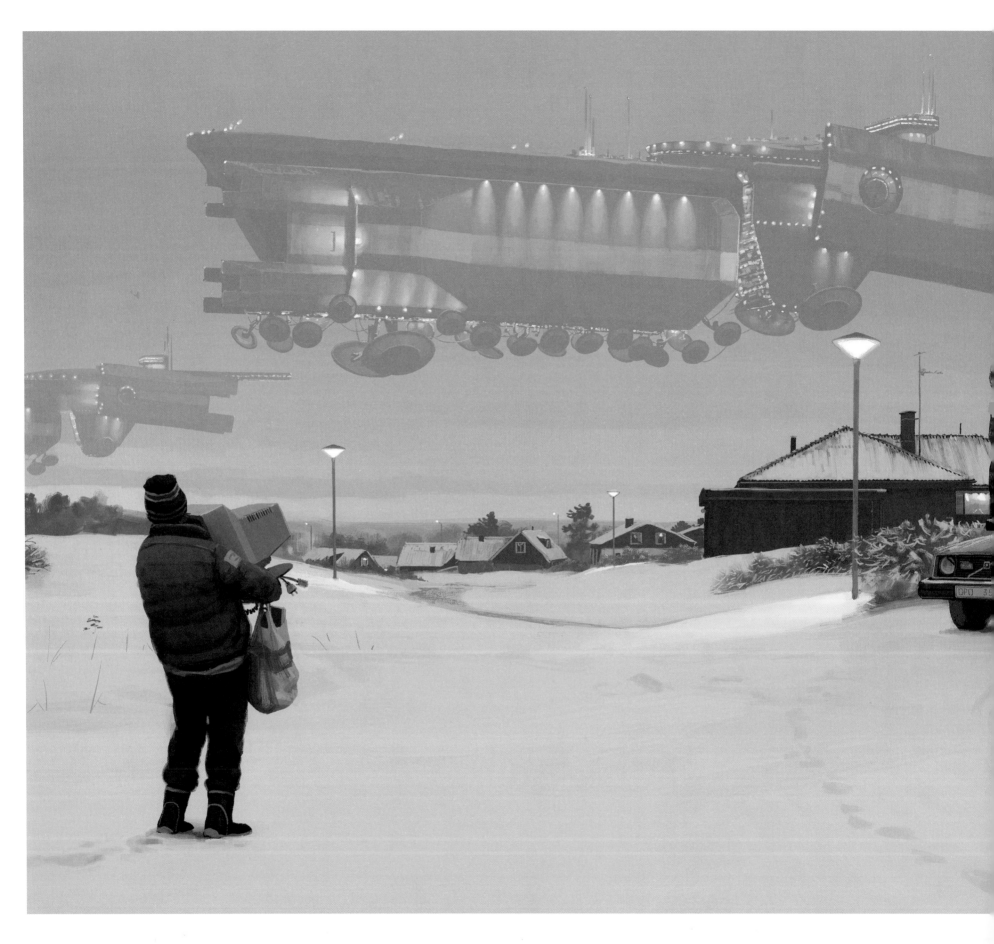

BERGGÅRDEN

We arrived in Berggården around three in the afternoon. After being checked by doctors and subjected to a series of tests, my mother and I ended up in temporary housing set up in the library in Berggården. It was a very nice refugee camp, I must say—full of light, food, neighbors sharing stories about the flood, and all the kids of the area running around among the bookshelves—but we did not stay long. The day after we arrived, as we were enjoying an improvised Christmas dinner, Lars Ribbing stormed into the library wearing his police uniform. Lars Ribbing was my mother's new boyfriend and also the only resident policeman of southern Färingsö.

I saw the huge ships arriving over northern Färingsö as we carried our things into Lars Ribbing's house. The sight of them stopped me in my tracks: such big ships rarely travelled south, and yet here they were: three enormous freighters at the same time!

I felt something ominous move inside me. Something had just changed in the world. It felt strange and frightening, but I couldn't decide if it had to do with the big ships or with Lars Ribbing's thunderous laugh from inside the house.

THE COMPUTER TARD AND THE HIPPOPOTAMUS

When the classes from northern Färingsö were merged with the classes in Berggården, the social slates were wiped clean. The old hierarchies ceased to exist, and I had no idea how to behave.

I ran back and forth on the bus, annoying my classmates. "YOINK!" I yelled as I tapped their heads. Some were angry and yelled "STOP IT, YOU RE-TARD!" Others laughed nervously with a look on their faces that said "he's insane." Knuckles, Jimmy Kraftling's personal thug, turned around, reached over the seat, pulled my shirt up, and pinched my love handles hard. "HIP-POOOOO!" he yelled between compressed lips. There was a sort of consensus in the bus: here we sit, 28 damned souls who have to put up with this hopeless individual. Even the teachers couldn't stand me when I was like this—if Rolf was on the bus he would grab me and hiss "NOW SIT DOWN!"

Worst of all was Jimmy Kraftling's reaction to my behavior—he simply stared at me with his beautiful Bambi eyes in a way that clearly said: you're an insect and you disgust me. This would throw me off balance and I would almost stop goofing around for a while. That required swift action, and under no circumstances could I show that I cared, so I threw myself into the aisle between the seats and ran with my shirt pulled up, chasing people with my blotched, heavy belly.

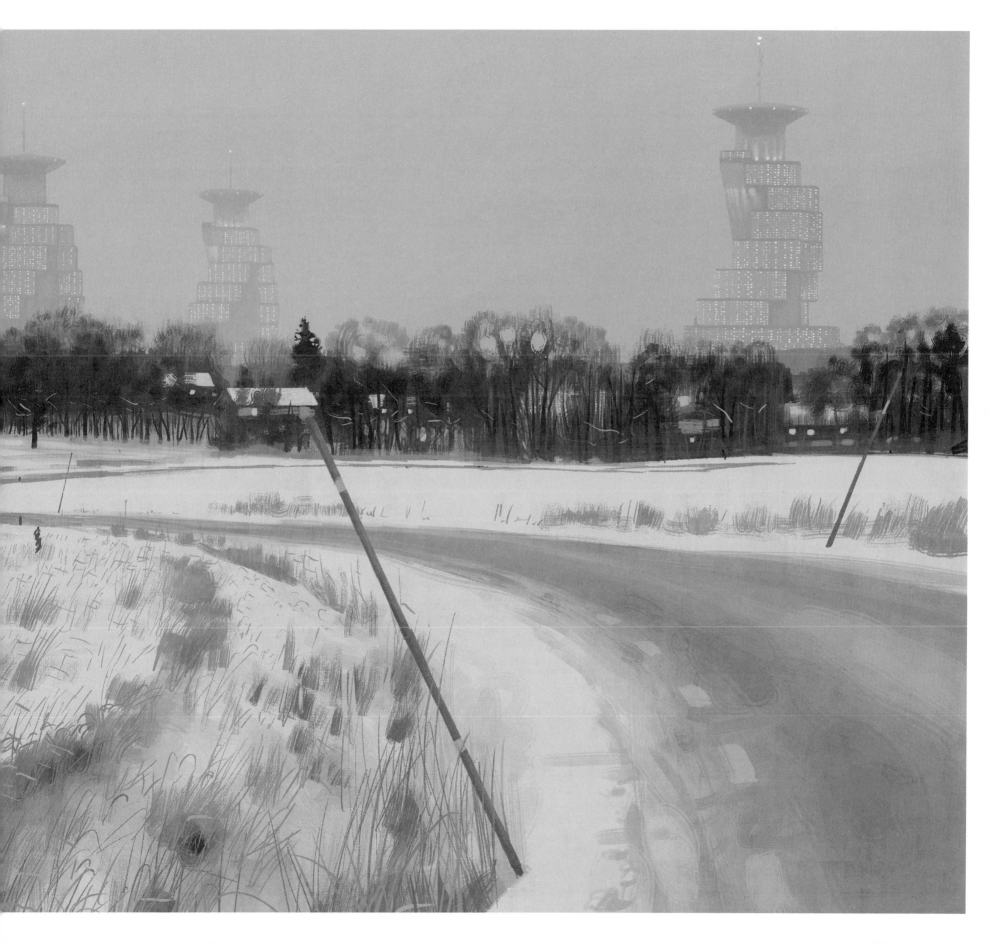

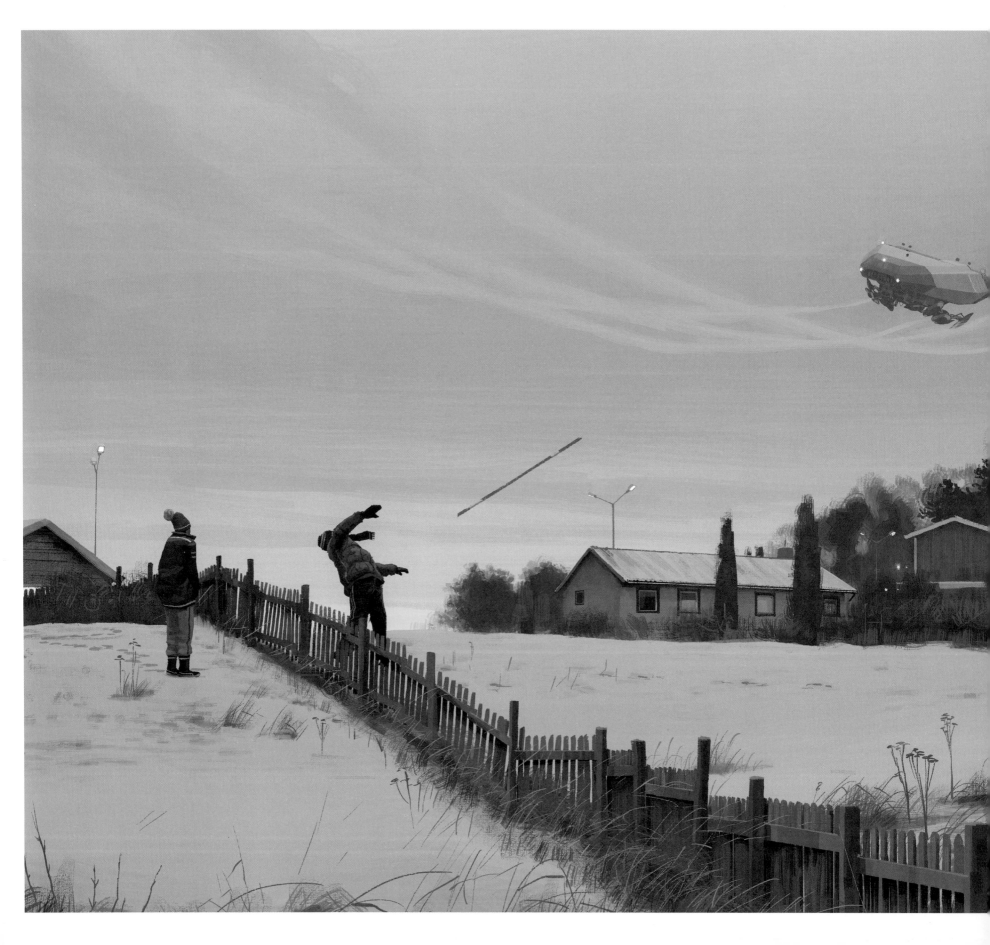

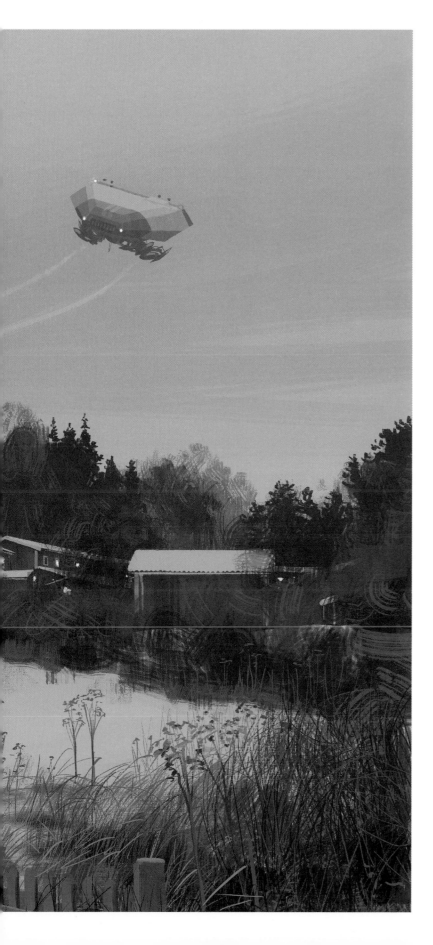

All that changed when I started hanging out with Lo, the small boy with big front teeth, who was called The Computer Tard. As it turned out, he lived in the house next to ours.

It's weird how these things happen. At first I really thought he was mentally retarded or something. I thought he looked strange with those buck teeth, and he had really strange vocal tics between words when he talked. I even avoided leaving the house when I saw him lurking about in the yard next door. But then one night Lars and my mother brought me over to Lo's family for coffee, and Lo showed me his computer and his books about robots. It was that simple. After half an hour we were best friends.

HÄGERSTALUND'S DIVING TOWER

I spent weekends with my father in Hägerstalund.

My father had moved there when the Loop was decommissioned, and what remained of his department was merged with Krafta Systems, which was the division of Krafta that developed and operated the computer systems in the company's facilities all over the country.

The apartment was at the bottom of Hägerstalund Tower, one of the twelve vertical cities in Mälardalen. They were built between 1965 and 1970 as part of a major public housing program, and Hägerstalund alone consisted of about 1,500 apartments. The ground level held a subway station, library, school, daycare, and shops. The tower was crowned with the characteristic water tower.

Once I heard a group of older boys on the bus talking about the Hägerstalund Tower and all the suicides that were supposed to have happened there during the Loop era. All the suicide victims were said to have been employed by Riksenergi, and they had been affected by the so-called "Loop Disorder" after having spent too much time close to the Gravitron down in the Loop. It had been an epidemic—evidently they never had time to clean up the brains from the ground before the next poor soul smashed into the pavement. After hearing this, I always glanced nervously up the tower every time I crossed the courtyard.

Other than that, spending the weekends there was okay. It felt like I could get some rest—Dad spent most of his time smoking in the kitchen, and I could use his computer as much as I wanted.

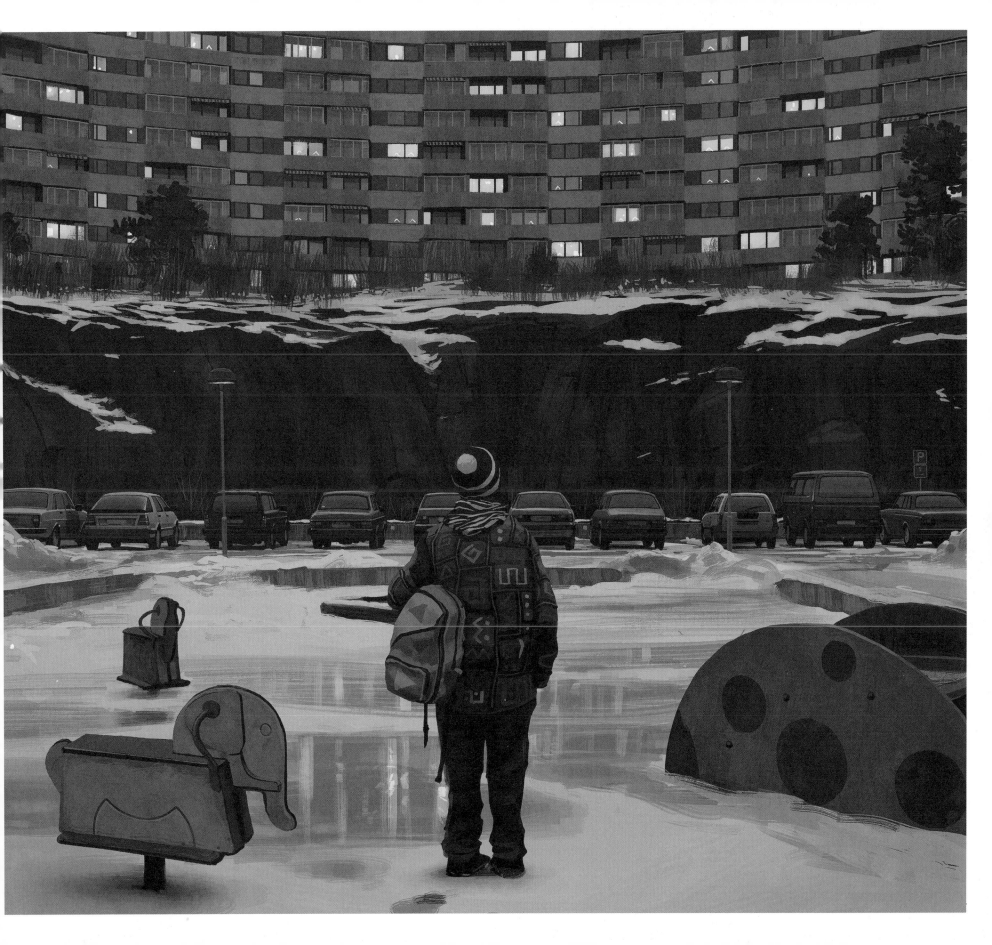

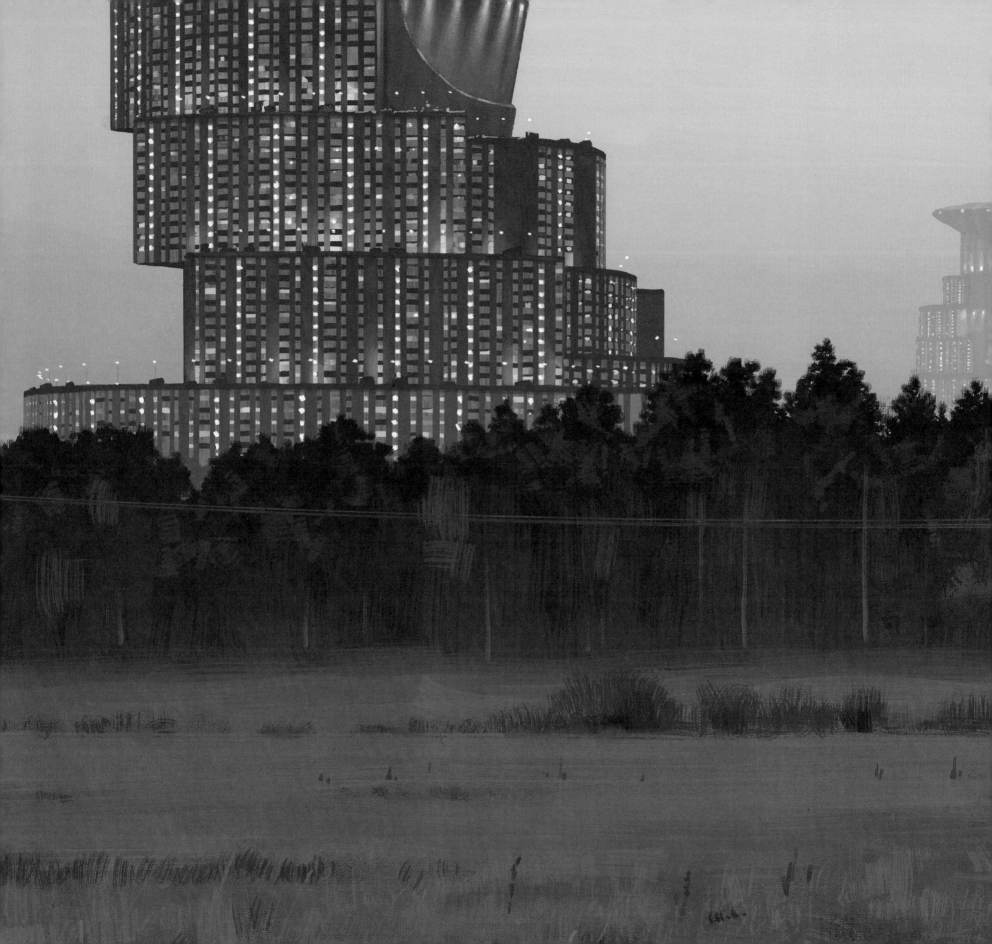

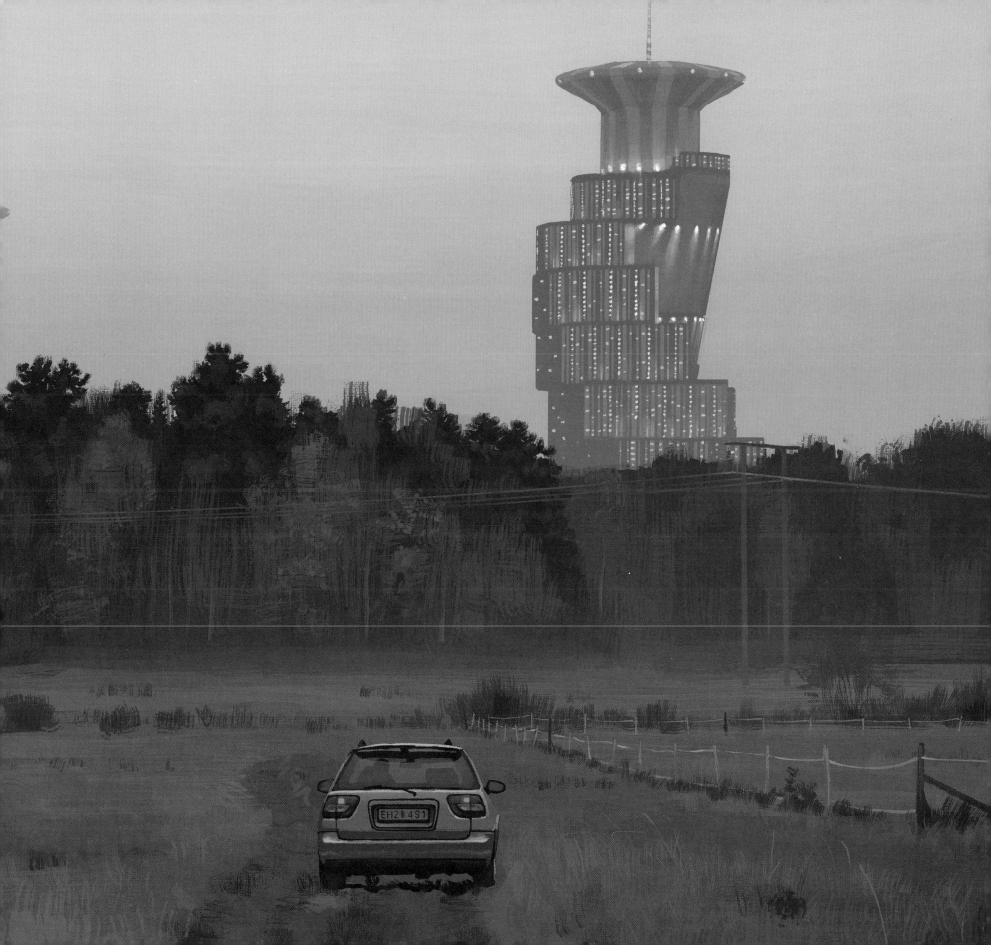

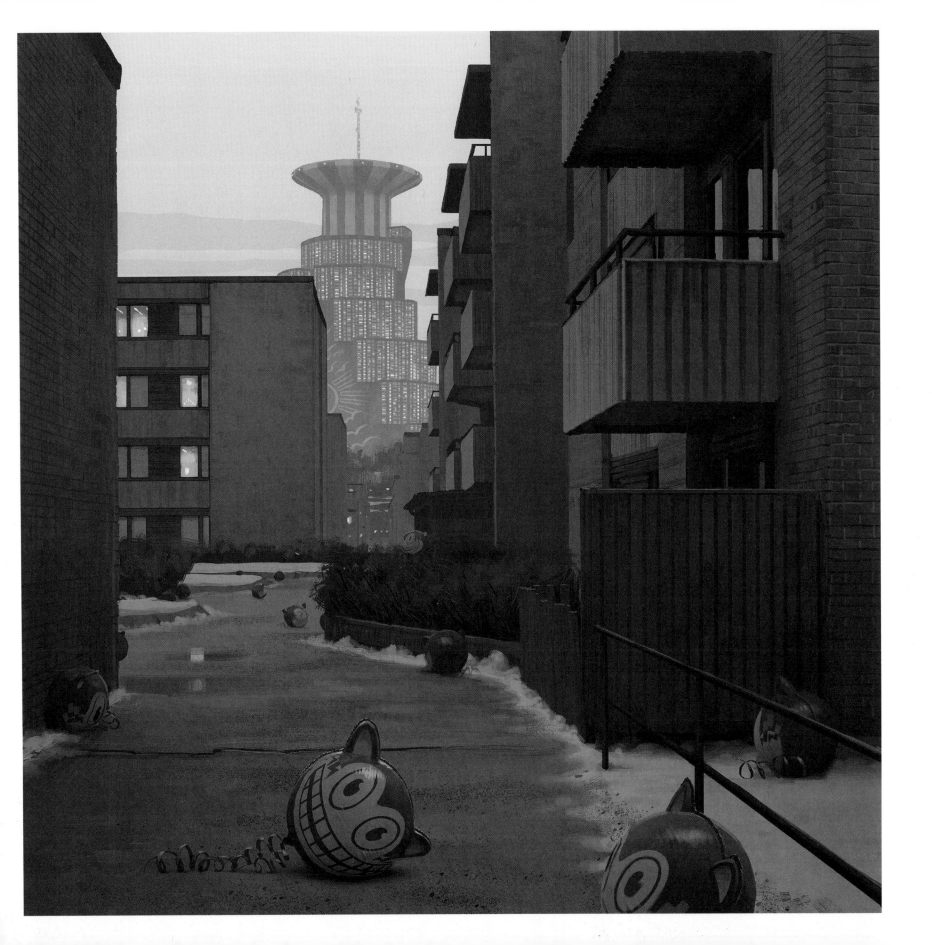

THE RUSSIAN TEDDY BEARS

"Russian teddy bears" were a kind of stuffed animal with a simple AI and a synthetic voice unit. They were supposed to be able to hold a conversation and have a personality, or at least the semblance of one. Because the use of AI in commercial products was prohibited in Sweden, almost all of the AI technology came from Russia, where they had a very different view of artificial intelligence and synthetic individuals.

It turned out that the used Russian bear my dad bought for me was almost completely useless. I had tried everything to get some form of response, but it never produced more than a weak, grating sound, and that was only if you squeezed it really hard.

So one Saturday, when I was bored and playing around with my grandfather's old pocket pistol, I had an idea. I would give the bear one final chance to prove it possessed some sort of reason. I took the bear out and placed it on the ground behind an electrical cabinet. "Sad little critter," I thought, or I may even have said it out loud. I took the gun out of my pocket and aimed it at the bear's forehead.

Then I got the reaction I had been hoping for. The toy bear let out a jarring scream that rose toward a horrifying electronic crescendo. I quickly put the gun away and kicked the bear. Its screaming shifted to hysterical rambling in what I assumed was Russian. It became embarrassing: the bear's heartrending gibberish echoed between the buildings. I picked the bear up and managed to get the battery cover off. That made the bear even more upset, so I pulled hard on the little cord and the batteries flew out and bounced across the asphalt. It was dead silent. I looked around nervously. A few of the tenants were looking out their windows to see what was going on. I picked up the batteries and the bear with trembling hands, and I stuffed it all into my backpack.

The worst thing was that I was really far too old to play with stuffed animals. And then this happened. And people saw me.

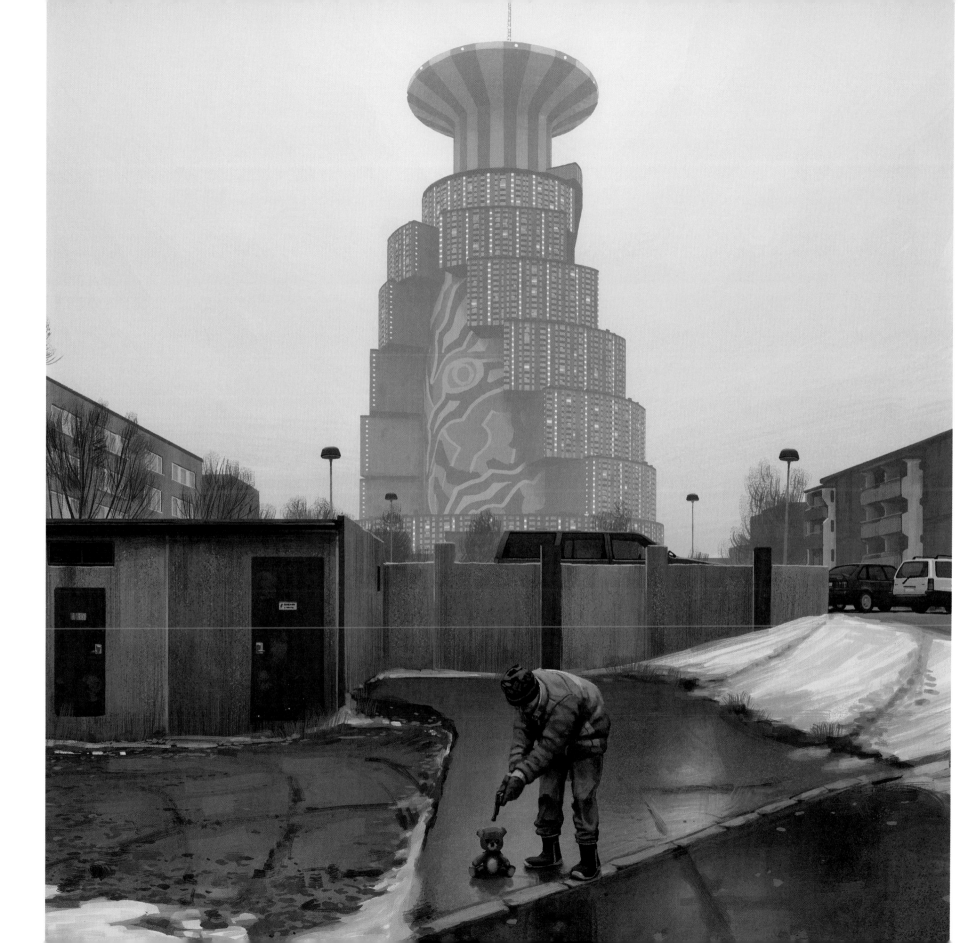

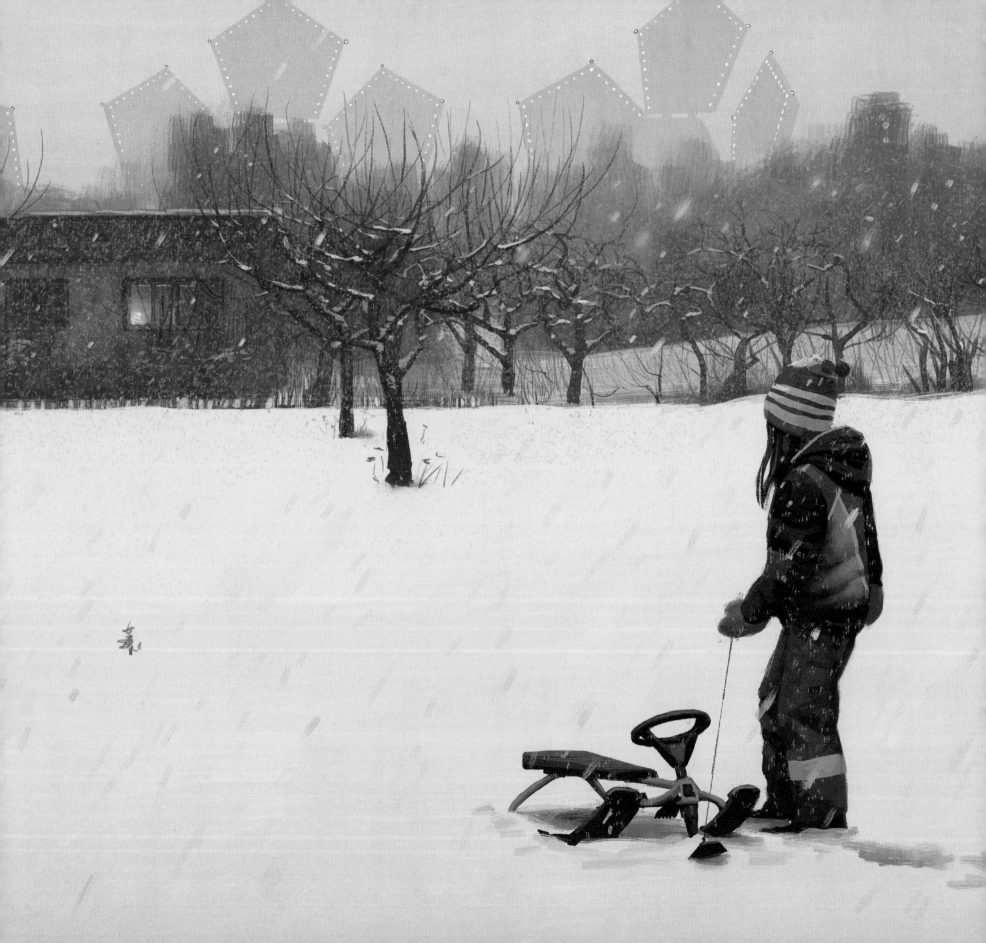

THE CLOVERS

The sign above the door to the auditorium in the Berggården school read "WELCOME TO ASS TEROID HALL!" I assume that the sign had read "Asteroid Hall" sometime in the school's ancient history. Like many other places in Berggården, the name of the auditorium was in honor of the Clovers facility, which was the observatory rising from a ridge behind Västerängen. We also had Sun Street, Star Alley, Space Village, Observatory Hill, and the very inventive Milky Way.

The strange radio telescopes had contributed to major scientific discoveries once upon a time. For example, formaldehyde had been discovered out there in the interstellar darkness—you know, the stuff used to conserve carcasses here on Earth. Grants dwindled, and in 1991 the facility was modified to track space junk on behalf of Krafta. Operations were mostly handled by computer programs, and from 1989 the staff had been reduced from two hundred and ten souls to three, including the two caretakers.

Among the elders of the community—those who grew up in the '30s and '40s, when the area was still idyllic farmland—there was great suspicion toward the Clovers facility and the monolithic telescope structures. The facility was blamed for anything: warm winters, cold summers, not enough chanterelles, too many snails, too many mosquitoes, or not enough mosquitoes. It didn't matter what, the Clovers facility was always to blame. So when the water flooded the homes on northern Färingsö in the winter of 1994–95, pretty much everyone over fifty was in agreement about what caused the disaster.

THE ASTRONOMER'S HOUSE

On screen the monster split open, turned inside out, and slithered to the floor in a bloody pile.

"BOOM! Check this out! CHAINSAW!"

He must have been well into his forties, but Stefan Eklöf had probably clocked more hours playing *Doom* than anyone else in the area. He had worked as a systems engineer at the Clovers facility in the 1980s, which was why some called him the Astronomer, and he had been one of the first to lose his job when Krafta took over. His house was overflowing with electronic gadgets, and it was the place where everyone in Berggården went as soon as they had any problems with their computers.

Stefan was somewhat of a demigod to Lo and I, and his software archive was the digital equivalent of the Library of Alexandria. A visit to him often resulted in my coming home with a stack of floppy disks filled with the latest games and programs. Software wasn't the only thing he gave away: if you got lucky, you could get old computer components he didn't need any longer. It was said that Jack Strömberg, in Class 5B, once got a complete computer from Stefan.

In the spring of 1995 we sat waiting to get a copy of *Doom*. When the last disk was being copied, he asked us if we wanted to see something even cooler. (Cooler than sawing demons apart with chainsaws? Impossible!) We followed him down into the basement, where he heaved open a large, round hatch in the concrete floor.

"This hatch leads straight down into the tunnels in the Loop. Look!"

He shone a flashlight down into the darkness. We leaned forward. A ladder disappeared down the concrete wall, straight down to where it plunged into dark water. Stefan's voice almost broke with delight.

"Extraterrestrial water from 51 Pegasi B!"

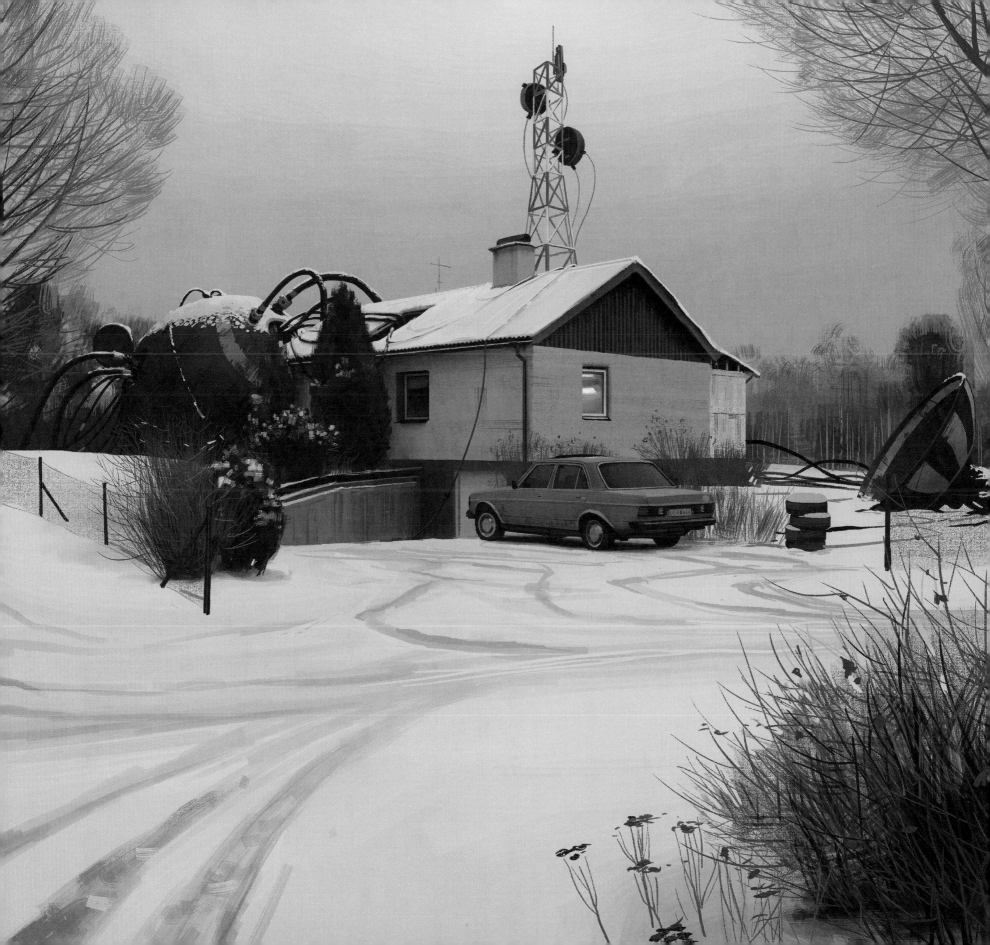

MODEM TIME

It truly was a spectacular salvage operation, and almost everything about it was strictly forbidden: the illicit disposal of the robot; the illicit disposal of Lars Ribbing's new wheelbarrow; the illicit conveyance of 15 kilos of rusty scrap metal into Lars Ribbing's house; and the illicit littering of Lars Ribbing's pedantically cleaned house.

My intent was to use the signaling receiver in the Creeper Sphere to connect to the internet without any kind of modem. The fantasy of being constantly online, completely unnoticed by the adults, was so enticing that I could accept severe physical hardships. Of course it all went to hell.

Let me say a few words about the modem situation. Any use of the modem in our house was strictly controlled by Lars Ribbing, and I loathed having to suck up to him whenever I wanted to be online. He didn't understand much about computers, but he did understand that modem time was important to me, and he found pleasure in being the highest authority controlling this strange commodity. Whenever I wanted to use the modem I was guaranteed an informative and pedagogic lecture about the rate-per-minute for using the modem, how Lars was paying the bills in this house, how it should come out of my allowance, and how this was really spoiling me, but that he was so damn nice that he would allow me to use it free of charge this time.

First of all, nothing happened once I had the robot on my desk and connected to my computer, per Lo's instructions. It was definitely powered up; the green signal lights were on, but the computer couldn't establish any connection with it.

Then Lars and my mother came home from the party earlier than expected, and I barely had time to squeeze the Creeper Sphere into my closet before my mother appeared in the door to my room to say goodnight. I was leaning unnaturally against the closet door and stumbled through a lousy improvisation about how nice and quiet everything had been at home. It was really a cosmic mercy that Lars and my mother were drunk enough to not notice the remains of my activities—the tire tracks in the snow in the garden, the wheelbarrow tipped on its side outside the garage door, and the leaves and twigs on the basement floor.

Once Lars and my mother had fallen asleep (Lars had passed out on the living room couch), I cleaned up any traces of my failed secret robot endeavor and cursed all the future lectures by Lars Ribbing, First Chief Supervisor of Domestic Finances, that I would be forced to suffer through.

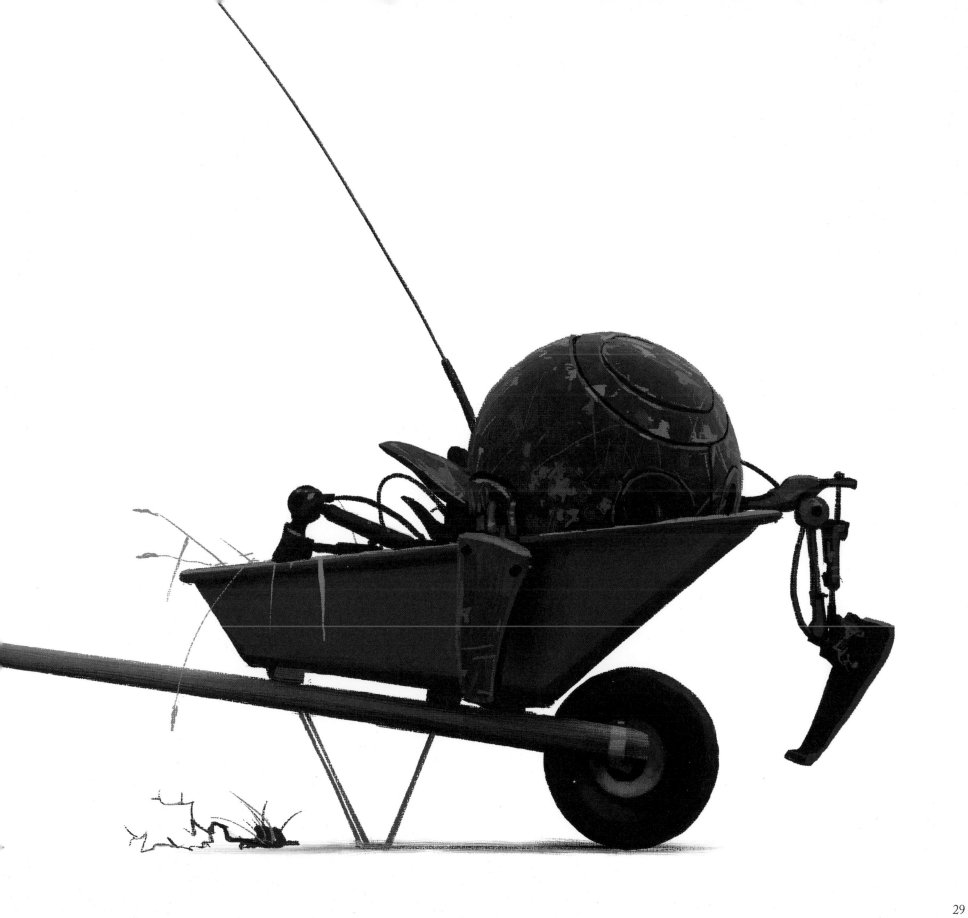

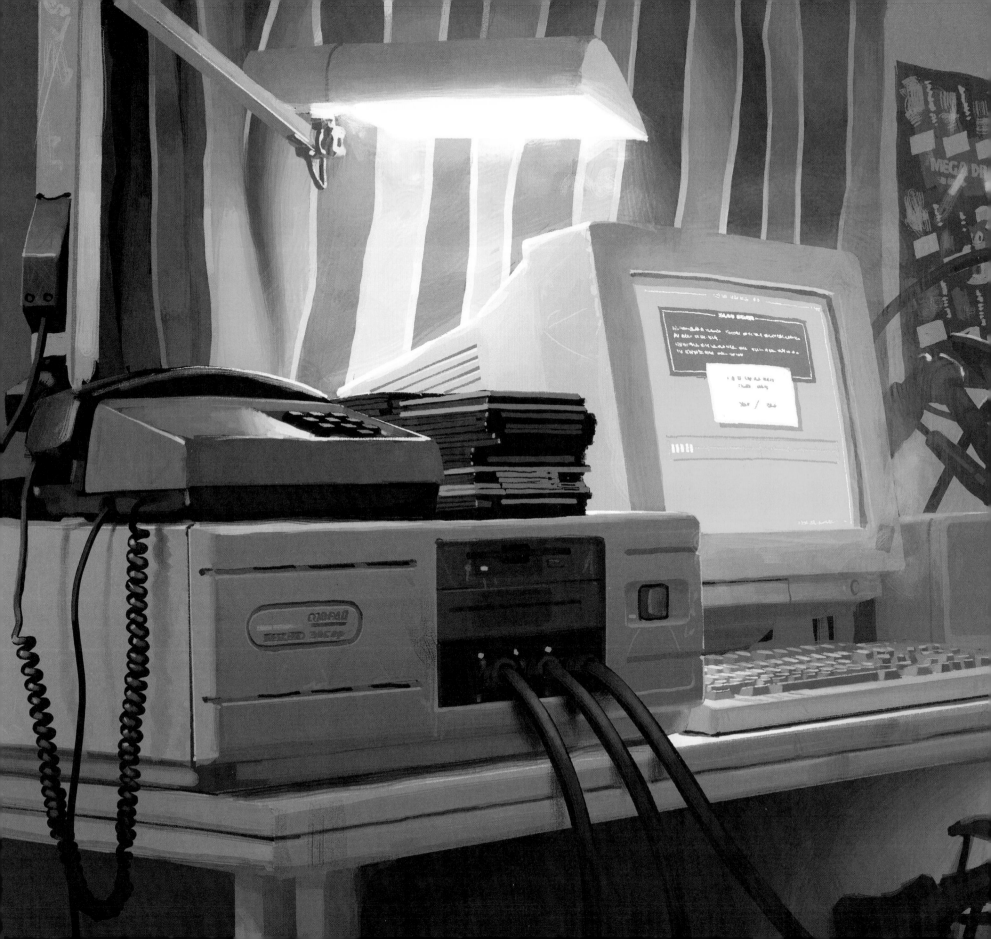

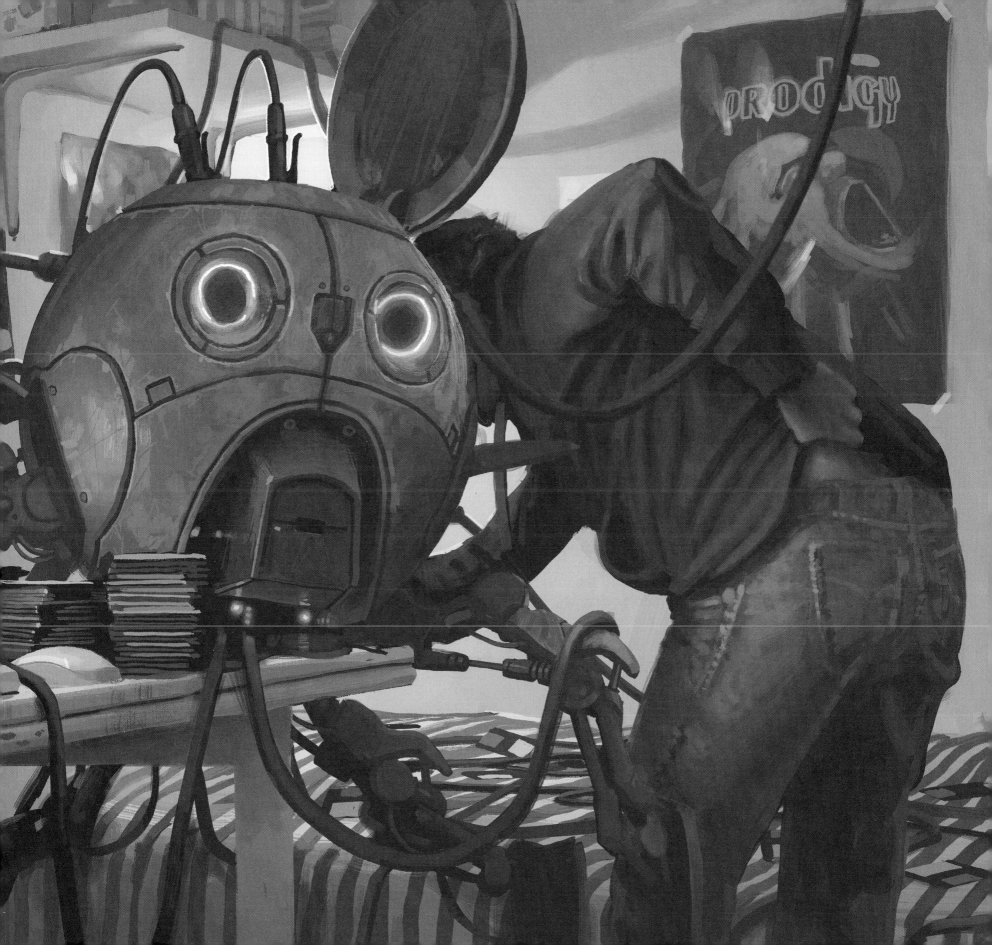

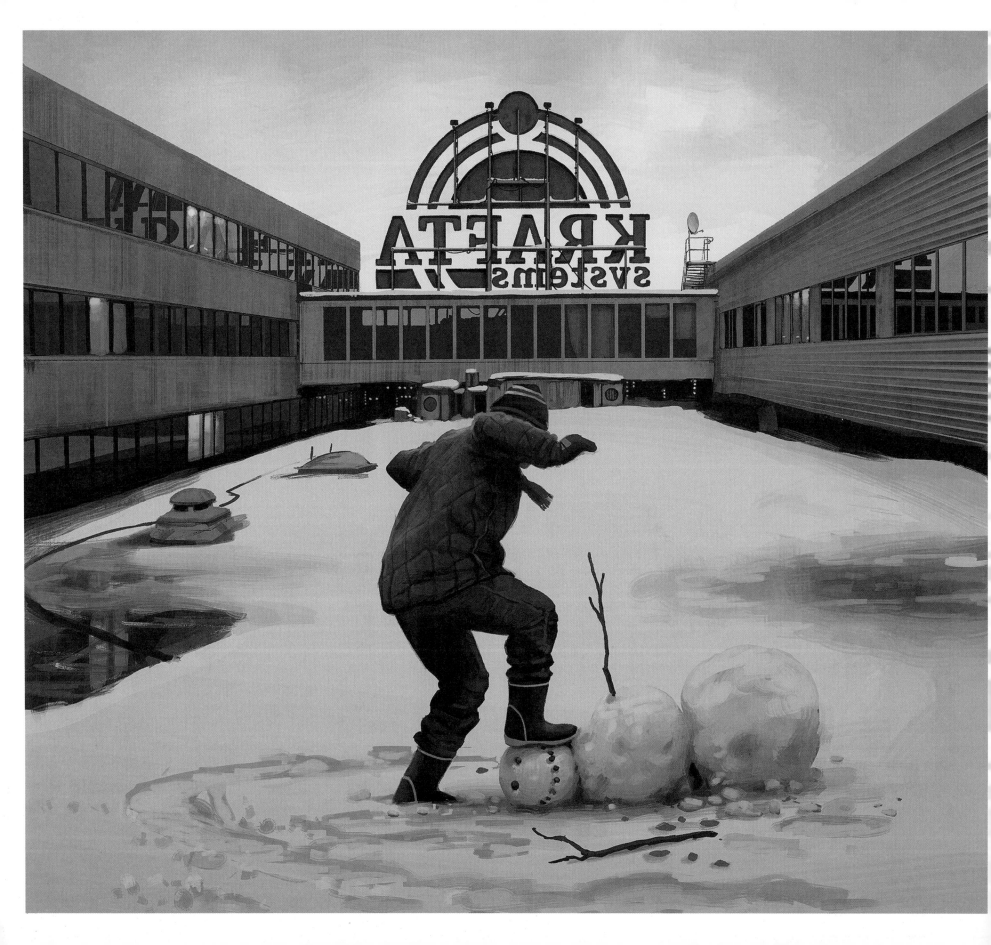

OFFICE LANDSCAPES

After the flood, my father's main assignment at Krafta Systems was to decontaminate hard drives that had been damaged by the water. Thirty years' worth of research data was slowly being eaten by corrosion. Technicians worked around the clock to save the precious information that arrived continuously from the flooded facility out on Mälaröarna.

I helped out on some occasions—sometimes I sat with my father down in the workshop and blow-dried circuit boards and hard drives—but most of the time my father was completely preoccupied with analyzing data, and there wasn't much for me to do but hang around and wait.

One late afternoon, in some kind of expression of guilty conscience, my father allowed me into the copy room where there was a computer that you could play games on. On the desk next to a paper cutter was a red floppy disk with Krafta's logo printed on it. Lo had told me to keep my eyes open for such red disks at my father's office; it could be a so-called SÄK5 disk, which was a type of key carried only by Krafta employees with very high security clearance.

My father lingered in the doorway for a long time, asking me about school and what it was like in Lars's house. He was trying to spend some kind of quality time with me, but all I could think about was that disk, so I answered his questions mechanically, hoping he would give up.

When he finally left me alone, I popped the disk into the computer and looked through its contents. It didn't look good—it only contained a text document. I opened the document and an image was slowly drawn across the screen. It was an image of one of my father's colleagues with a red plastic ball on his nose. He was grinning and holding up both his thumbs toward the camera. Text emerged below the image: "Welcome to Torsten's and Agneta's annual masquerade: '4th Floor Fun Fest' on February 24."

I slammed my forehead down on the keyboard in defeat, and a long string of t's scrawled across the screen.

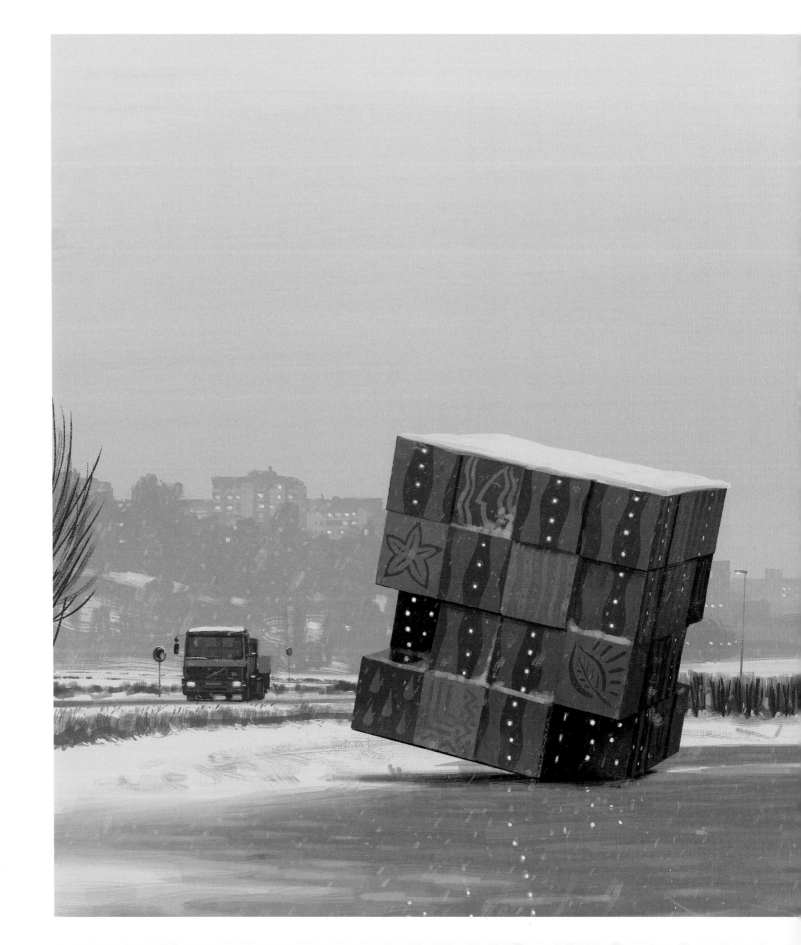

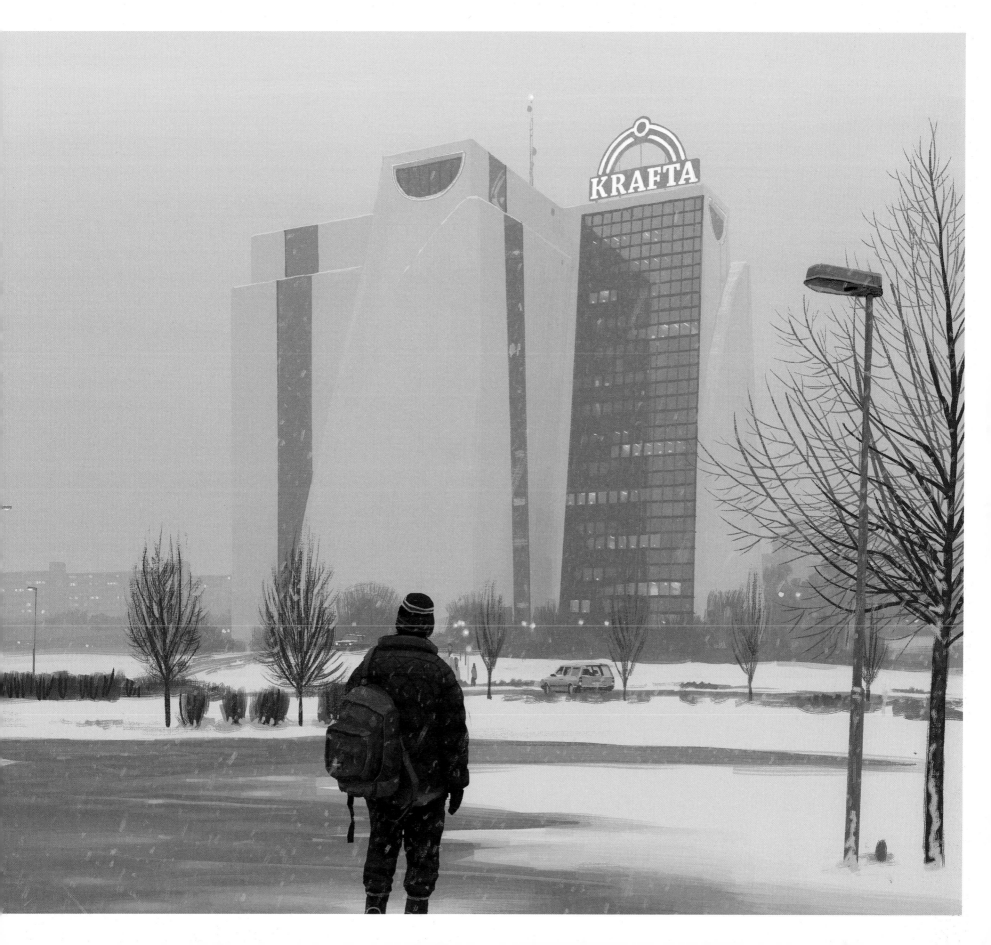

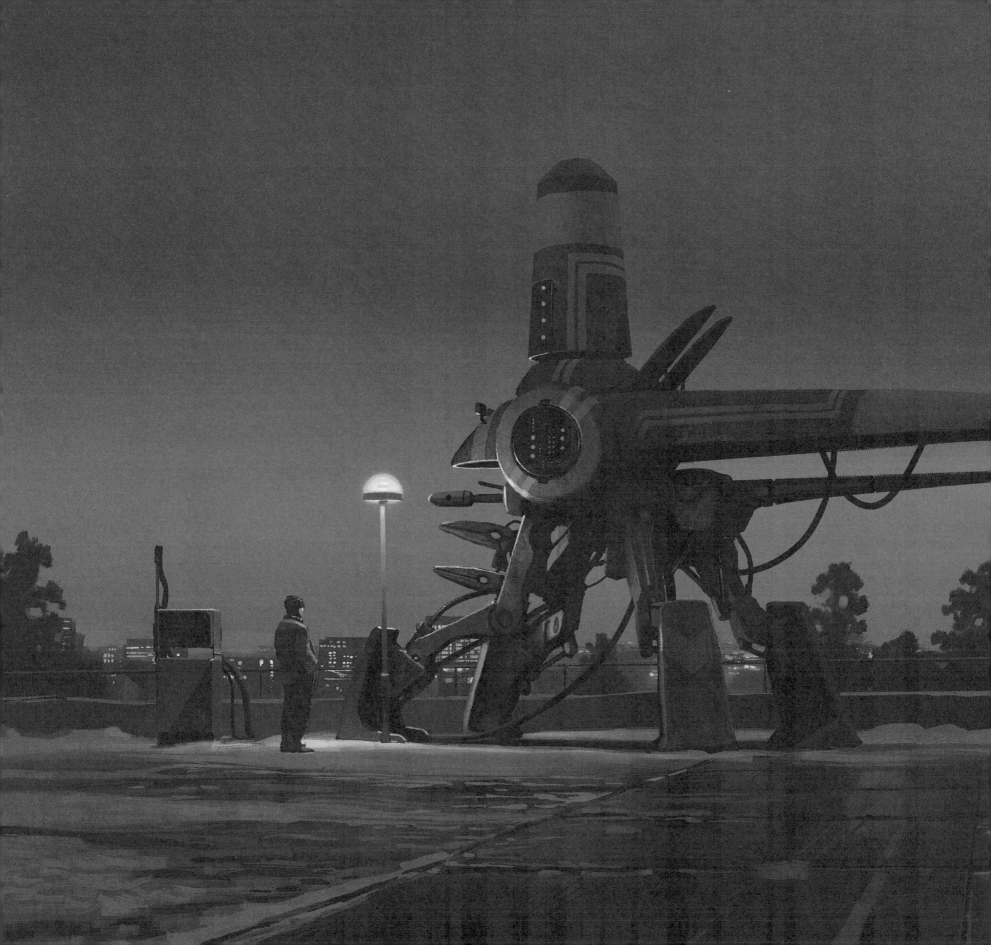

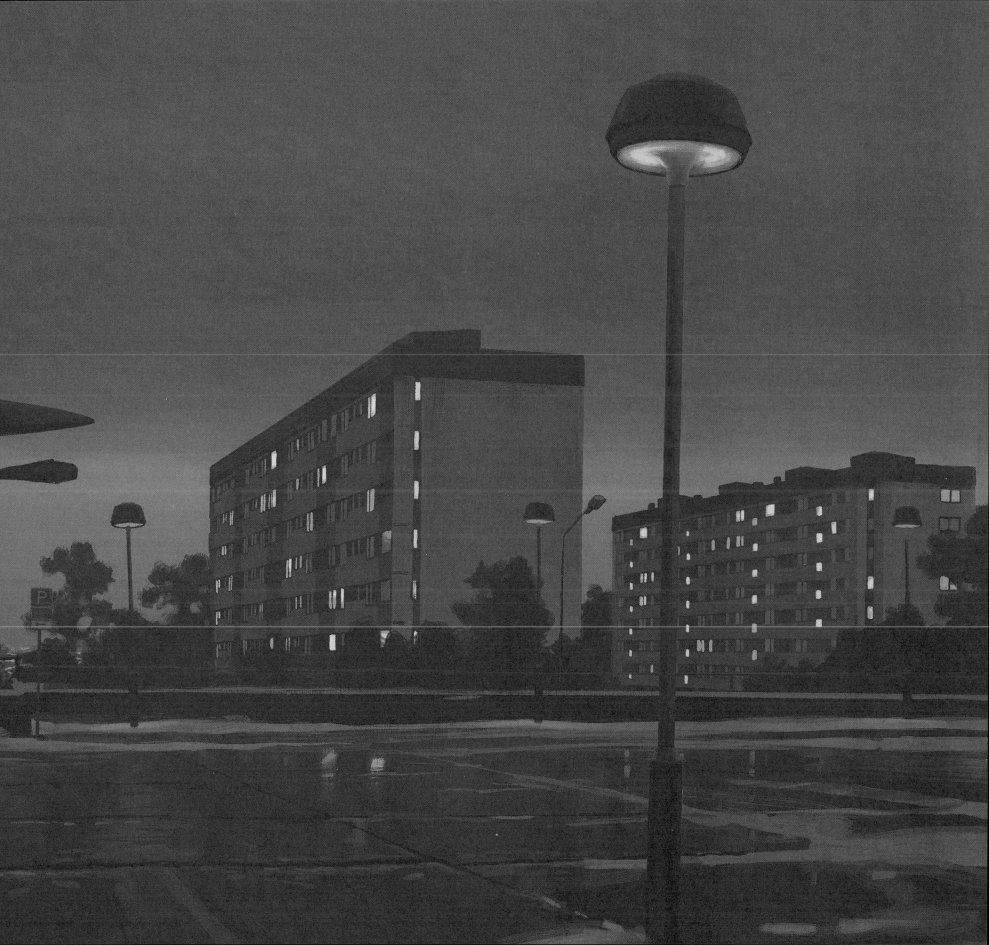

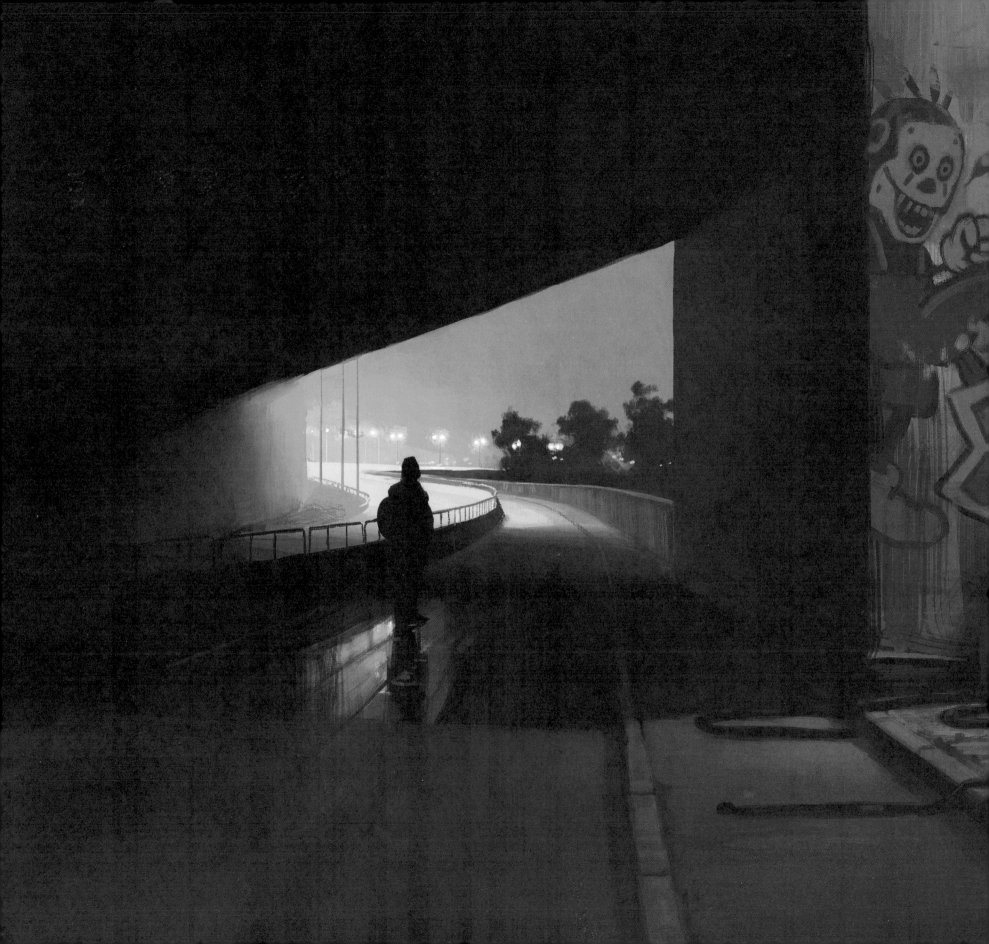

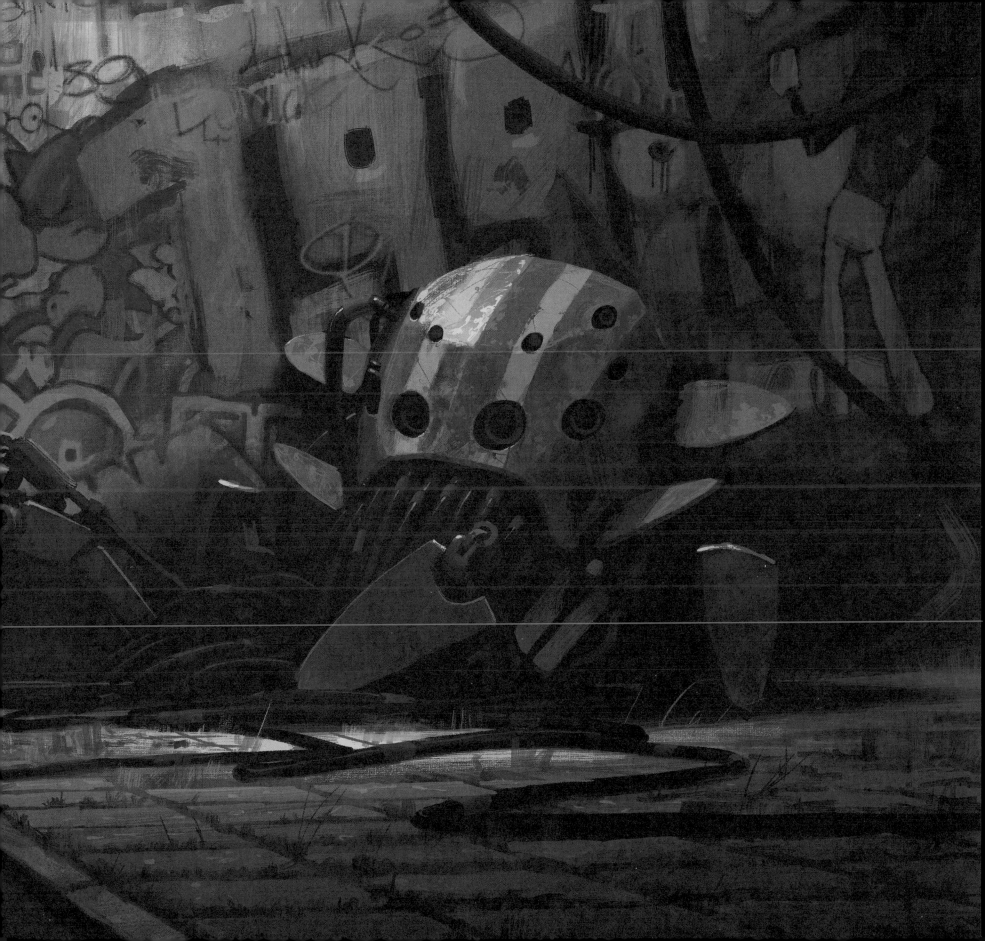

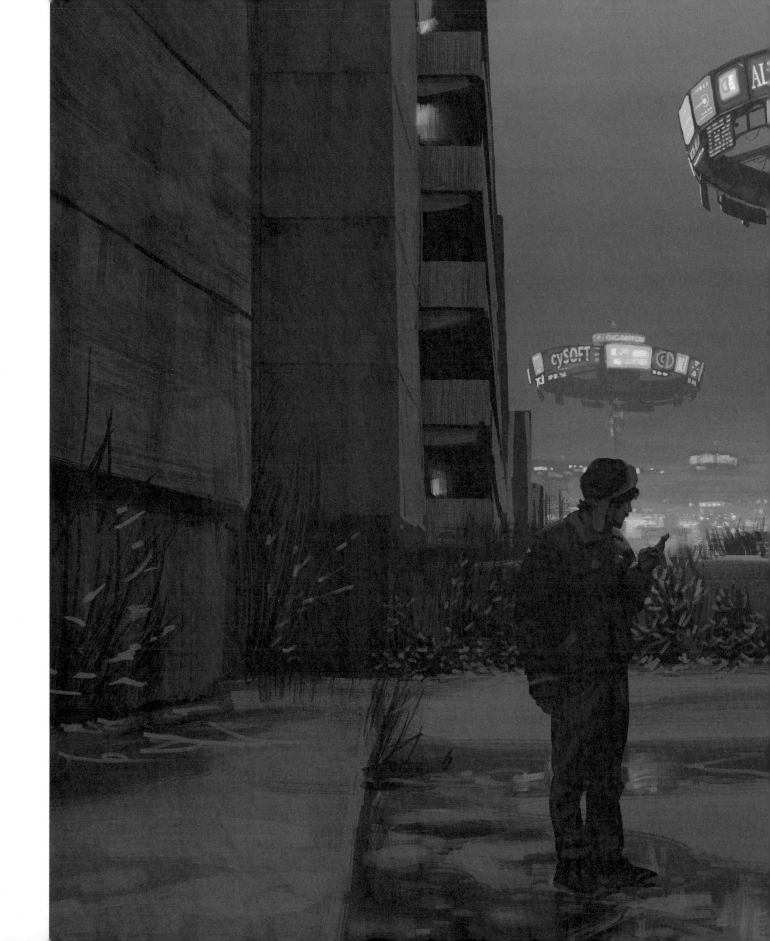

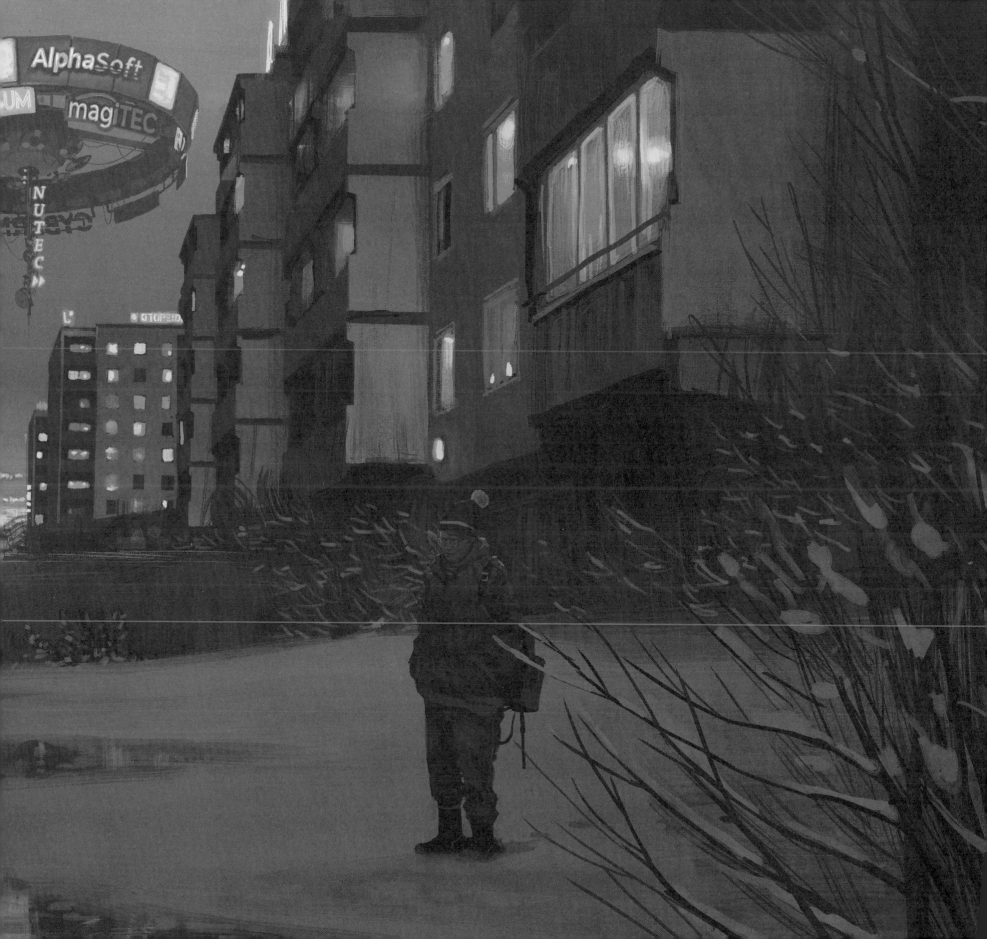

UNLOCK. EXPLORE. REPEAT.

I stood there with itchy gloves and boots full of snow. The heat flowing up from the Loop had melted the snow completely from the hatch. I wiped the snot from my upper lip and looked back at the pole with the old disk lock, and I realized that I still had the disk that I had stolen from my father's office. It was in my jacket pocket. I wasn't expecting anything other than the usual "INVALID ID" that was always the result of inserting your own disk in a disk lock, but it was still worth a try. I shuffled through the snow to the lock, opened the cover, and inserted the disk. After a long silence the reader inside buzzed and the display lit up:

```
CONFIRMING ID.............................................. OK
ID: SÄKS APPROVED
WELCOME BJÄRED, TORSTEN
```

My heart dropped five meters. It had worked. Without thinking, I pressed the big green button marked OPEN, and a mechanical screech cut through the air. Behind me, I saw the blinking of yellow warning lights—the hatch was opening! I struggled through the snow and up to the open hatch. Steam rose from the dark abyss. A ladder descended into the darkness. This was dangerous, forbidden, illegal, and so awesome. I made a snowball and held it over the hole. Warm, moist air flowed up, carrying a scent that reminded me of the furnace in our old house.

I dropped the snowball. It disappeared down into the darkness and the universe held its breath. The air stood still. My heartbeat thundered in my ears, the snow creaked in the bushes, and a bird took flight somewhere.

And there it was: the sound of the snowball hitting water, deep down in the flooded innards of the Loop.

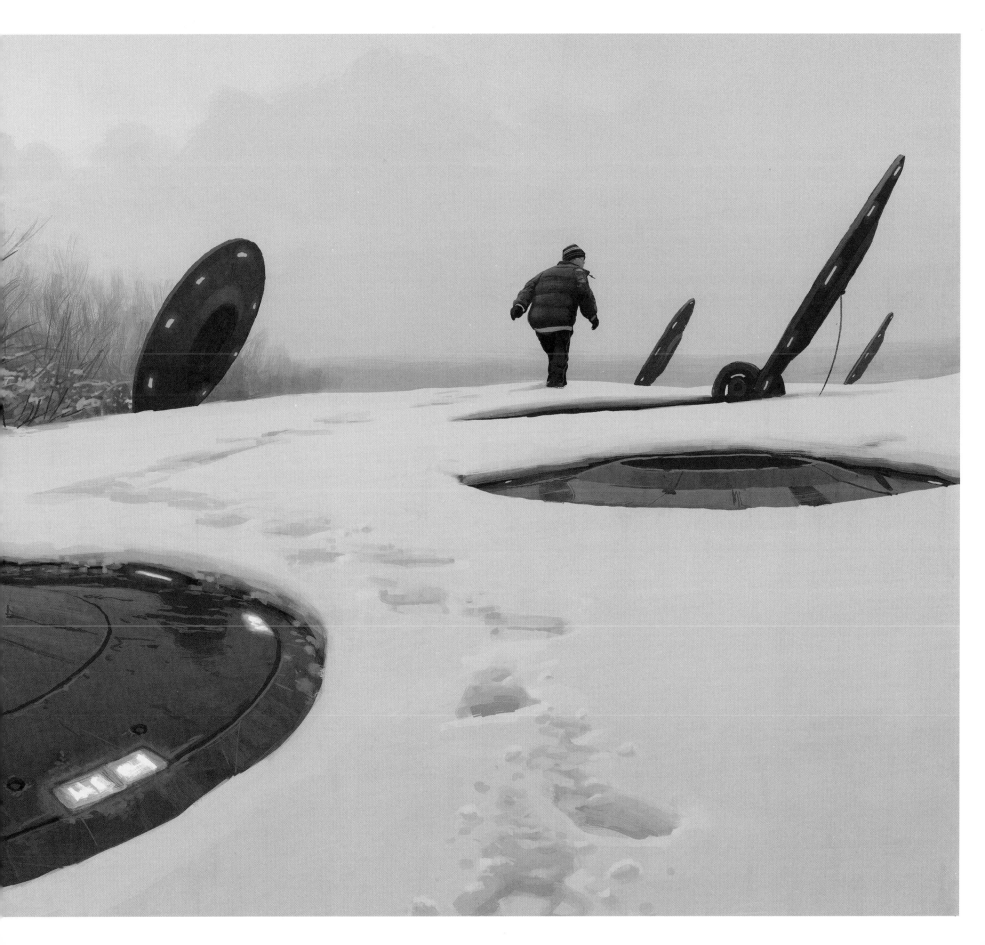

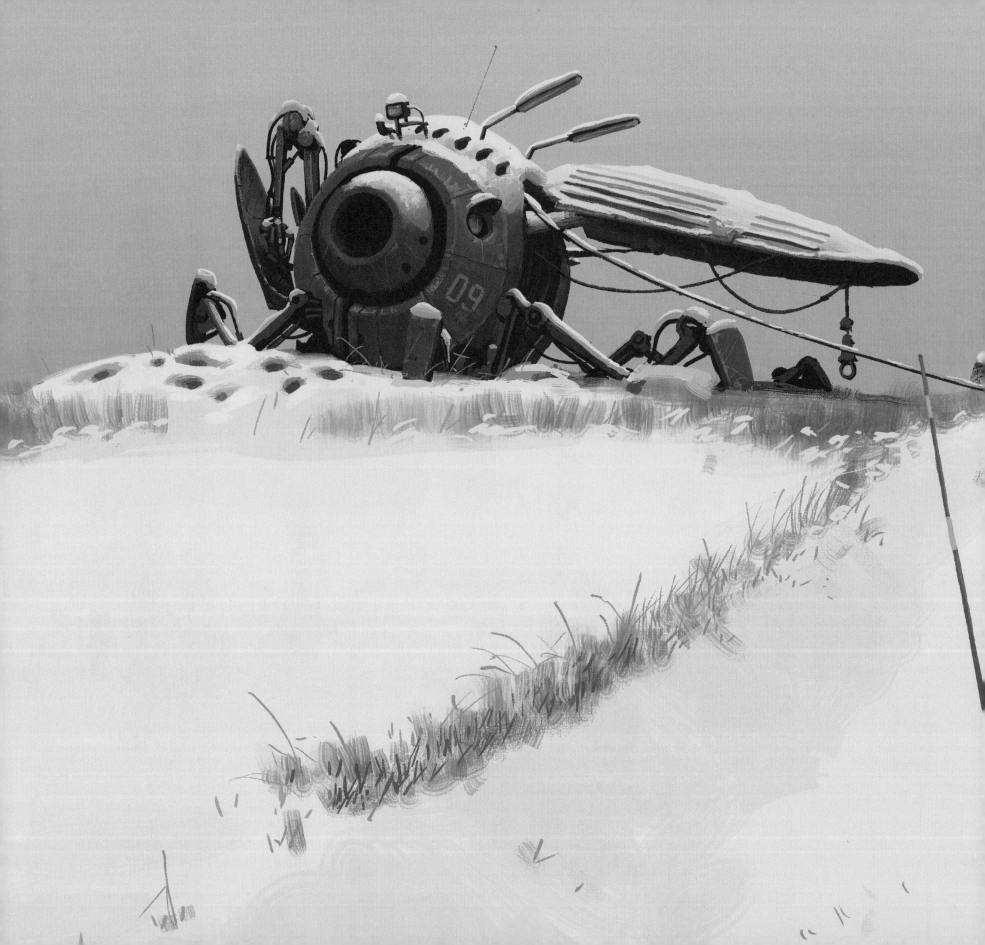

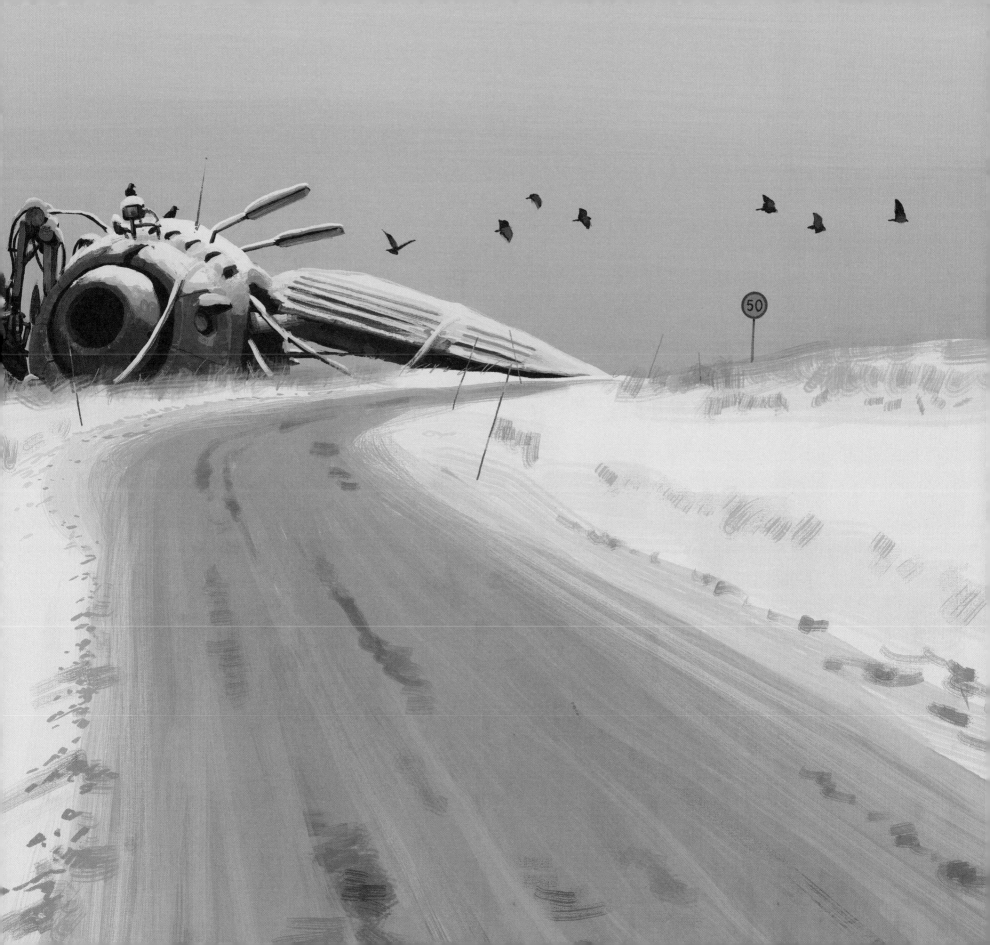

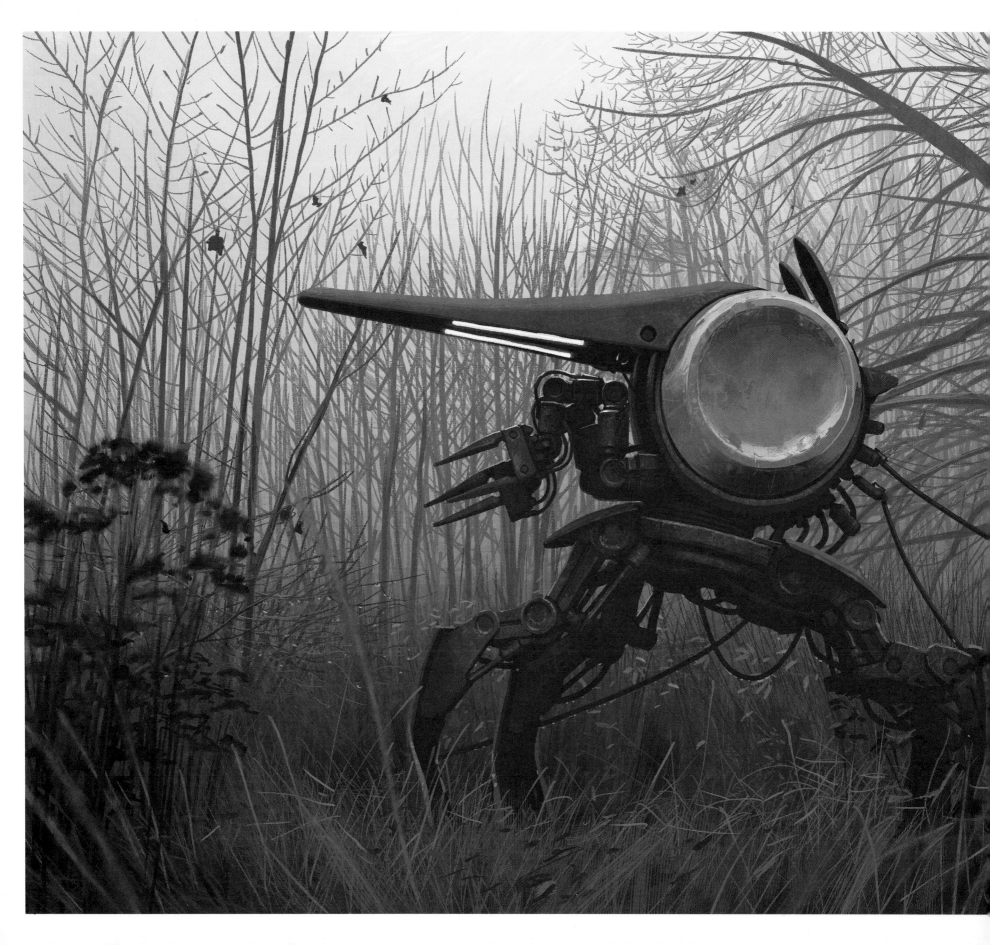

COVERT OPS

After I had stumbled upon the SÄK5 disk, Lo and I had been promoted to commandos on secret missions deep behind enemy lines. We had compact binoculars and notepads, and we could spend hours in the evacuation zone. Lo took this very seriously and, even though we didn't have walkie-talkies, he still insisted that we end every sentence with "copy" or "over and out."

"I observe five men at the barracks at two o'clock, copy."

"You secure the western flank and I will secure the eastern, rendezvous behind the oak tree, over."

"Foxhound, update your position, copy."

Lo never wavered.

An ALTA quadruped was recharging in a glade behind a storage shelter in Sånga-Säby. It patrolled in slow circles, and the challenge was to get as close as possible without being discovered. Lo loved this game. He wanted me to divert the robot's attention by throwing pine cones into the shrubbery behind it, so he could run up and check if the door to the storage shed was locked.

"Our unit is starving. There may be provisions in there. Over," Lo whispered. I was wet and cold, and those pincers scared me. I whispered as quietly as I could that I didn't want to play anymore, but Lo didn't answer. He was busy observing the robot through our binoculars. I tried again.

"Foxhound requests permission to return to ba—" I was interrupted by a sudden snap among the twigs on the slope behind the robot. In terror, we watched as the robot twirled around with shocking speed, and we saw how it moved across the entire glade in a second, like a lightning-fast spider. A frightened pheasant flew out of the shrubbery, cackling in terror, and narrowly avoided the robot's pincer, which snapped through the air behind the bird's tail.

Lo stared at me, terrified, and hissed: "Request granted, return to base, over and out." Then we ran.

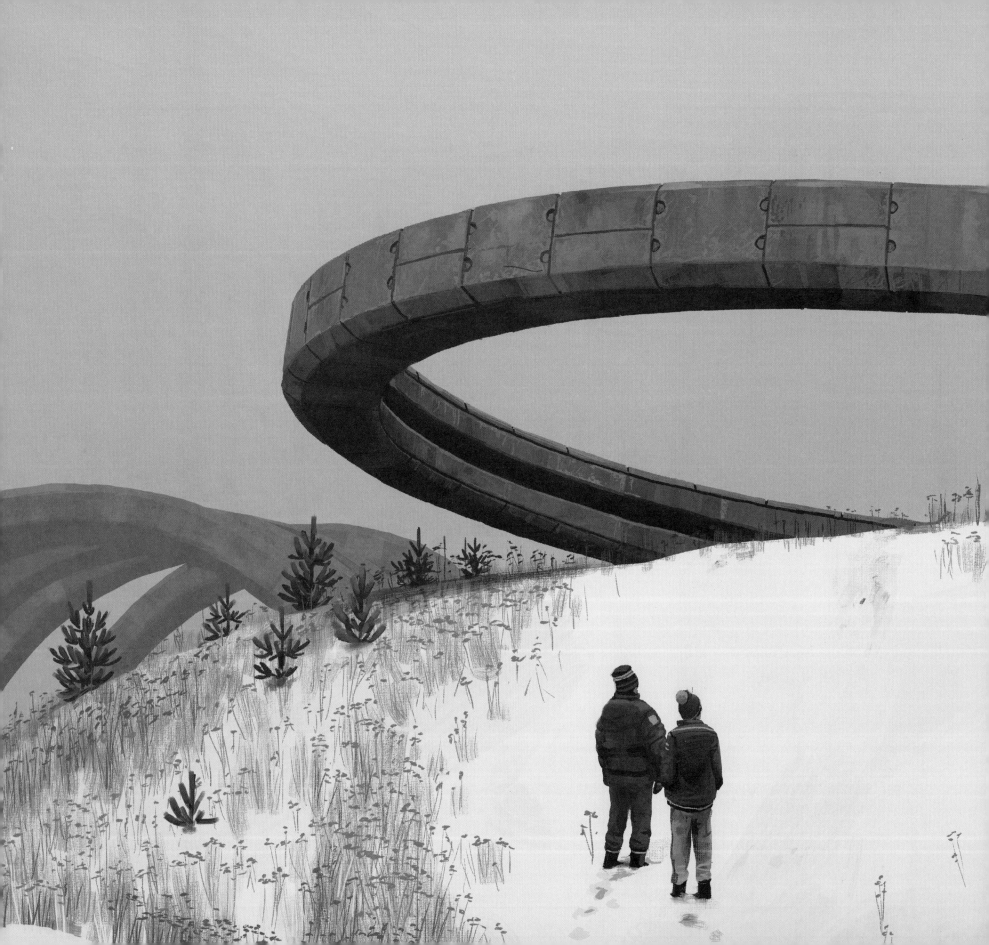

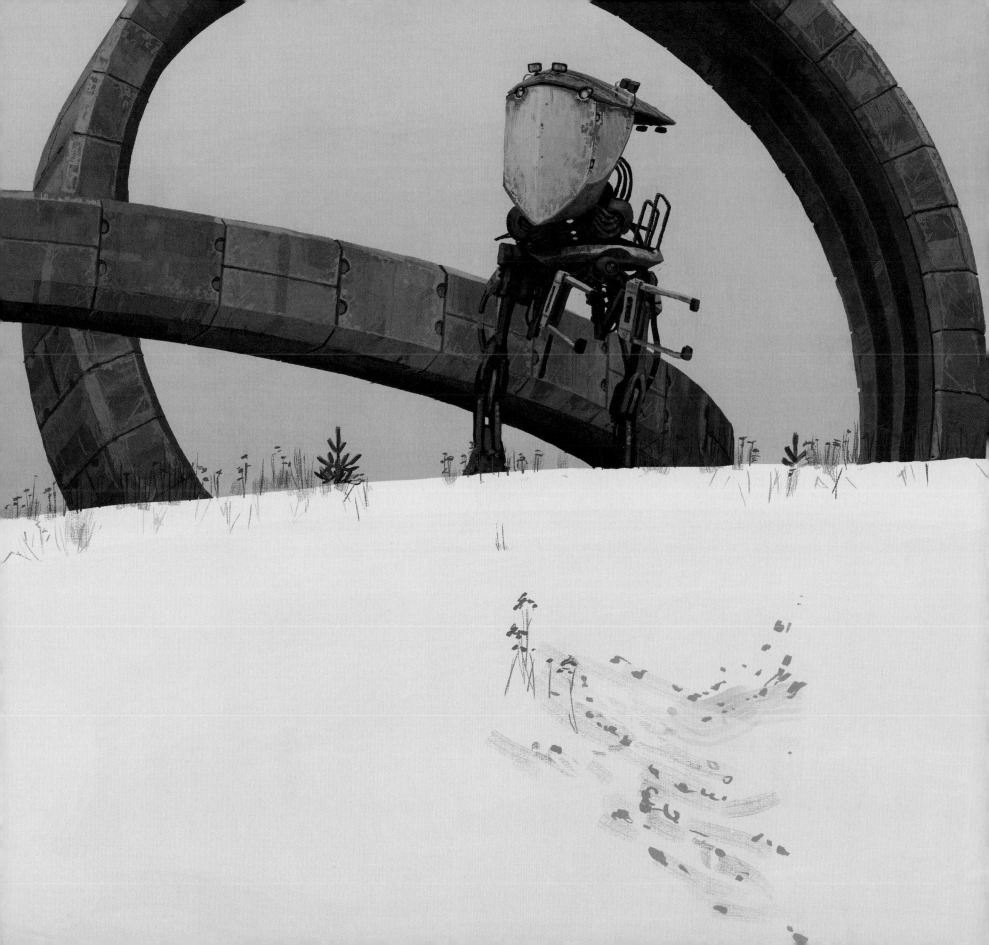

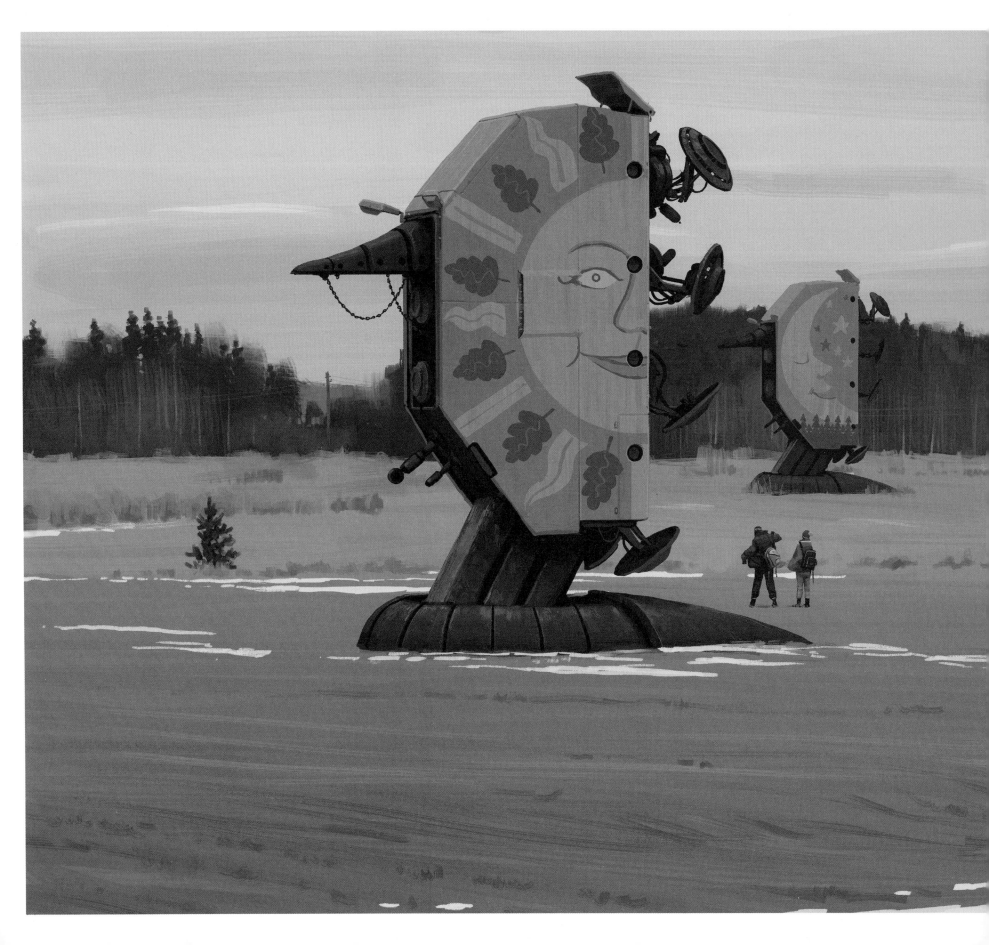

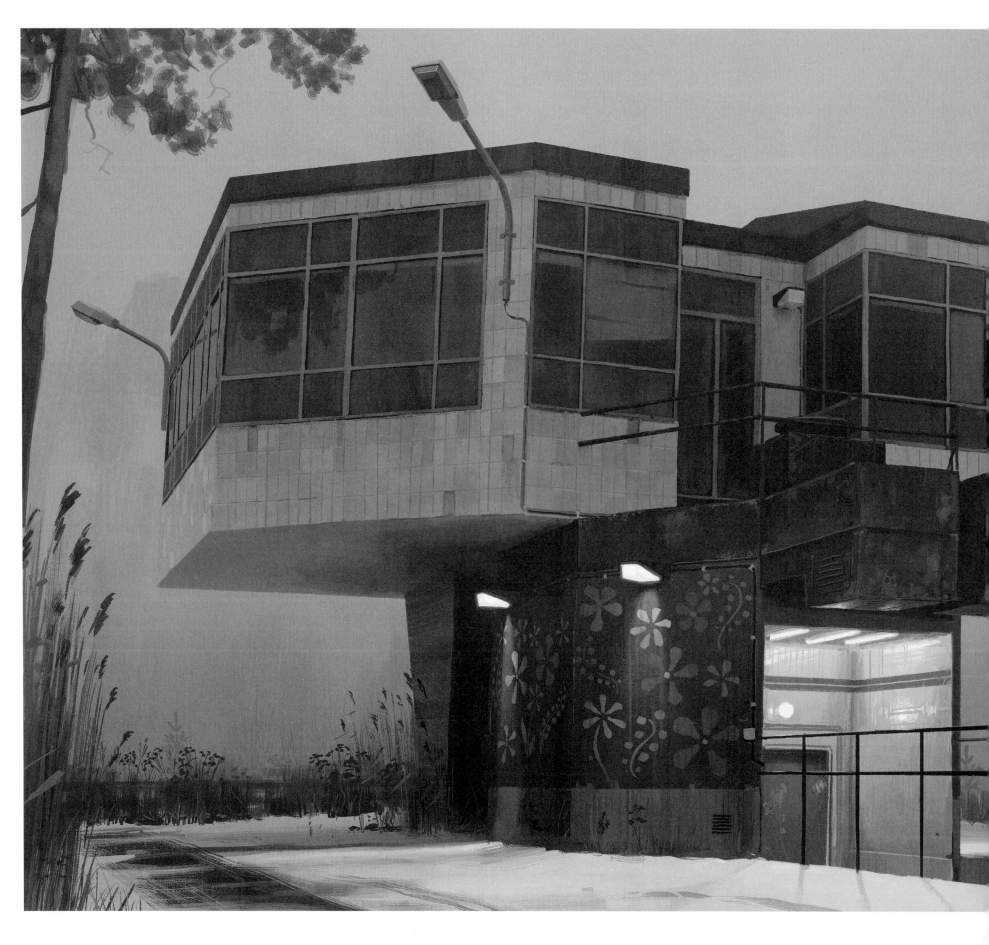

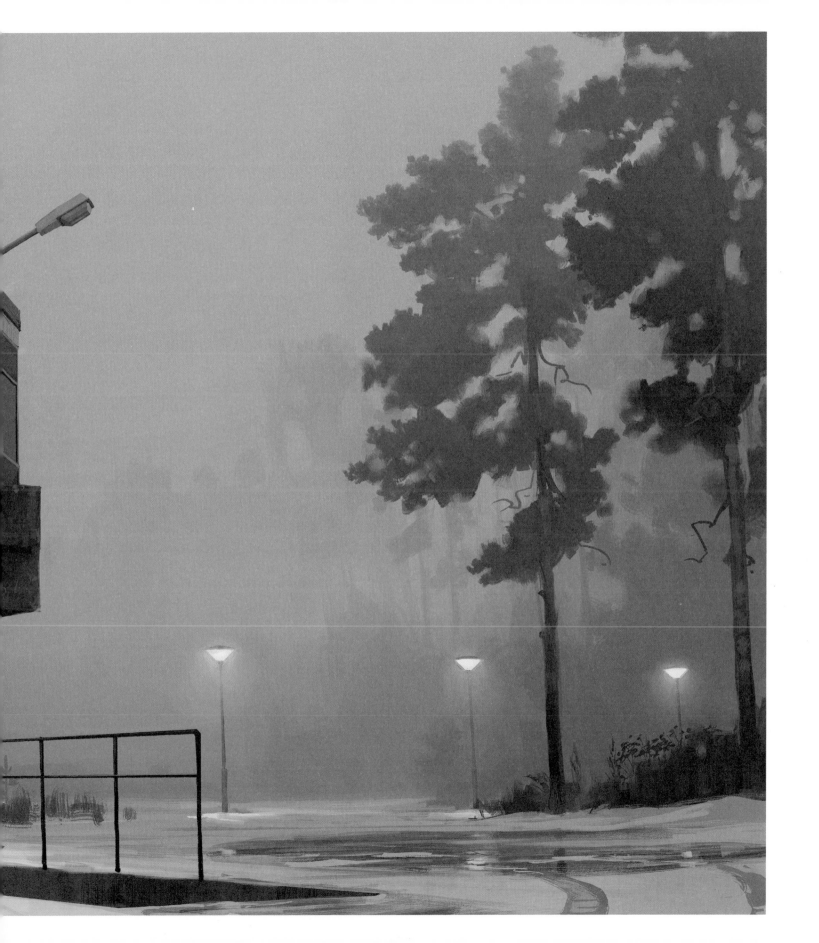

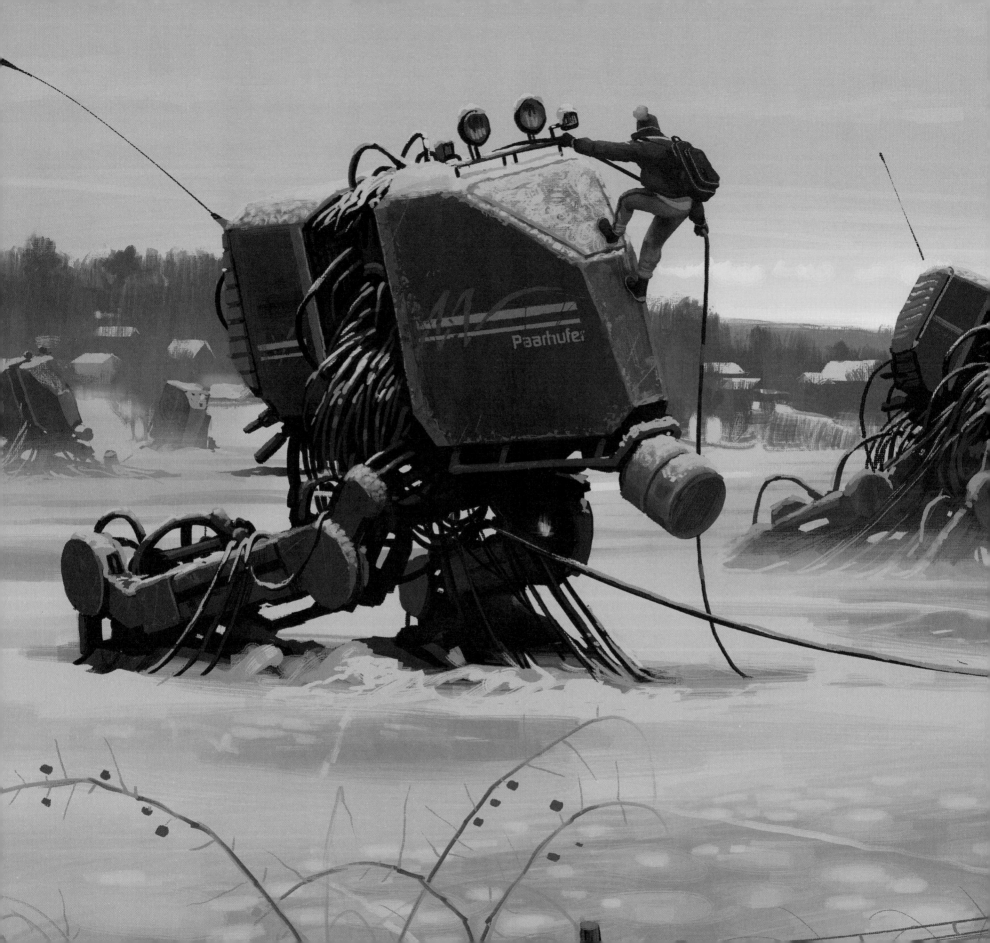

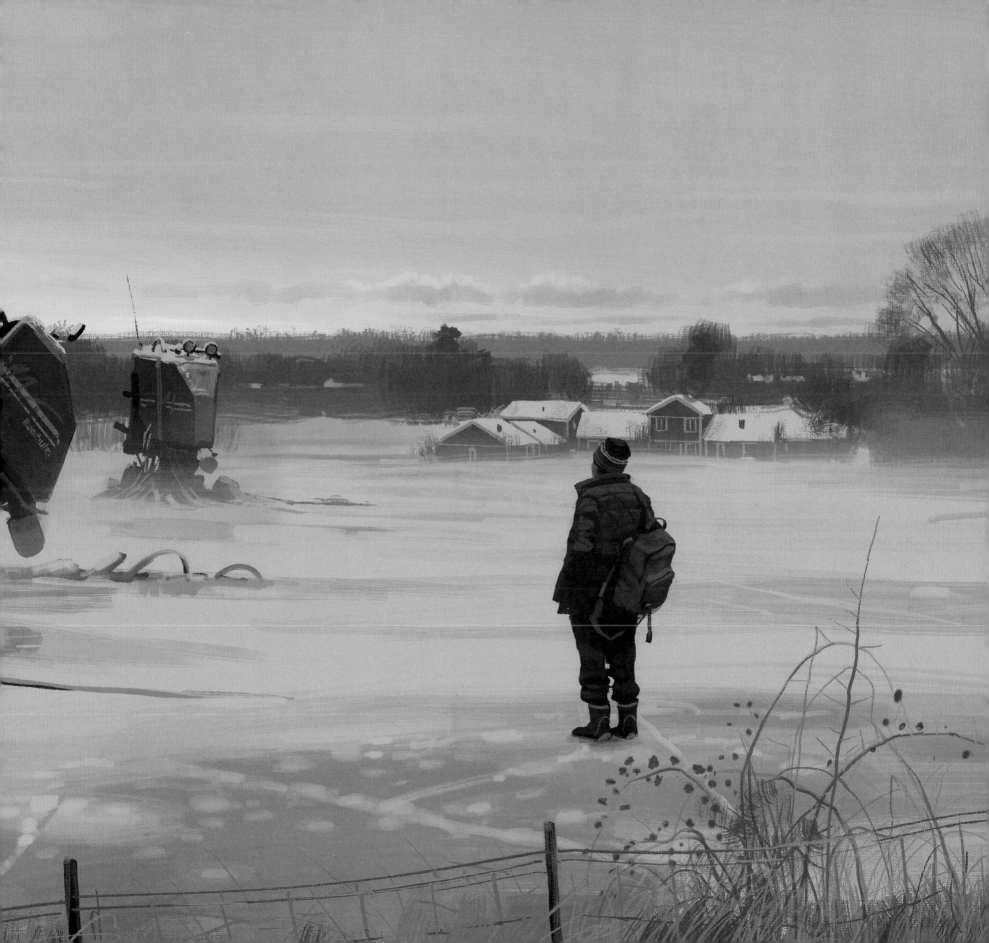

SEBASTIAN SEUFFERT'S DRAGONS

Was Sebbe suffering from Loop Disorder? Some people thought so. His father had worked down in the Gravitron, and Sebbe never came to the community youth center. He had spent an unhealthy amount of time down in the Loop, waiting for his father's shift to be over.

We never found out the truth, but I do remember that Sebbe smelled bad. I don't mean puberty sweat, but an odor of a kind that made you realize that something was wrong in his family. It was a stench that he brought with him from a home filled with insanity. He almost never talked, but simply sat quietly in a corner. When the class was divided into pairs to work on some assignment there were always problems—sometimes students stated openly that they didn't want to sit next to Sebbe "because he smells bad." Cue nervous giggles.

I felt sorry for Sebbe, and I walked him home from school a few times. He barely made a sound.

After the flood, notes about runaway cats appeared on the bulletin board outside the library. It was a cat plague, some said. Others claimed it was related to the flood. Sebbe finally moved to a special needs school in Norrtälje sometime during early spring, and a rumor started going around that he had been behind the cat disappearances. A Krafta service technician was said to have found him on a wooded headland in the fields behind Solbacka, covered in blood and sitting in the middle of the aftermath of a cat massacre. They said at least fifty cats had been spread out around him, gutted and cleaned like fish.

Like I said, Sebbe was usually very quiet during those walks from school, but I remember him saying something that made no sense at the time, but which would make the whole cat story more chilling later.

"You have to come to my place and make cat food. We can make cat food together and feed my dragons. They are growing quickly now."

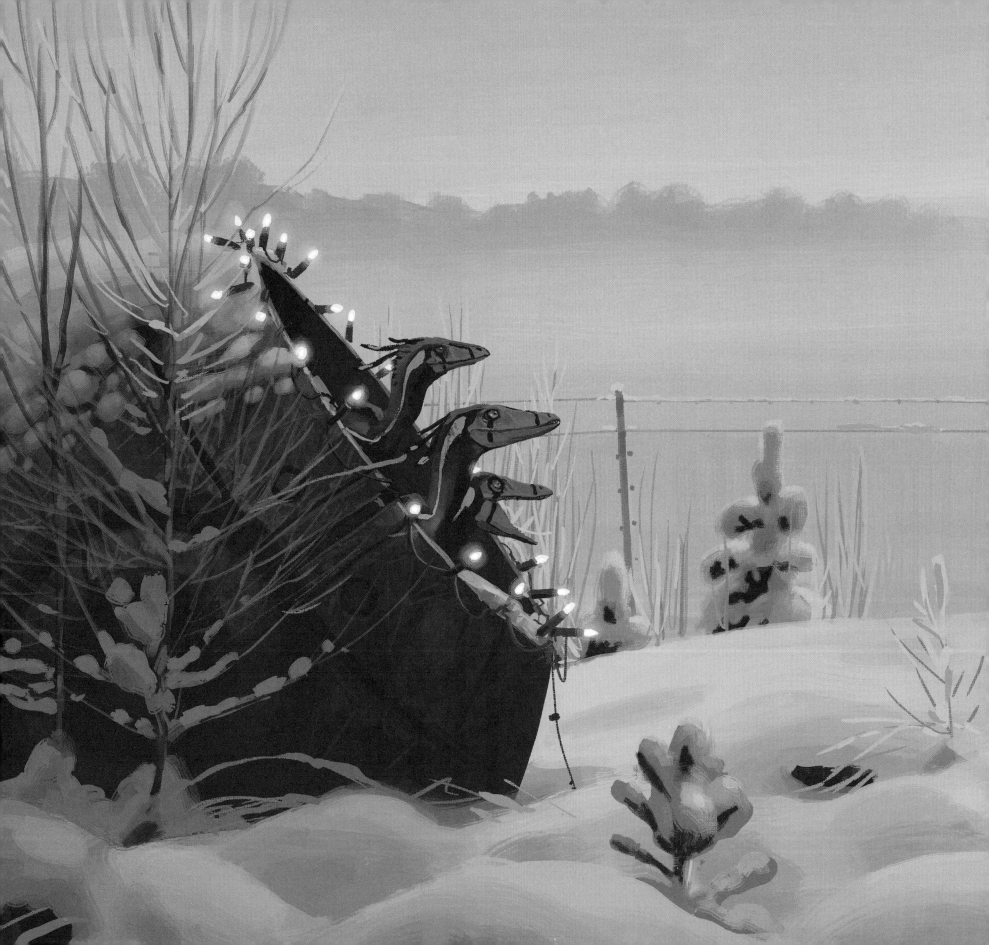

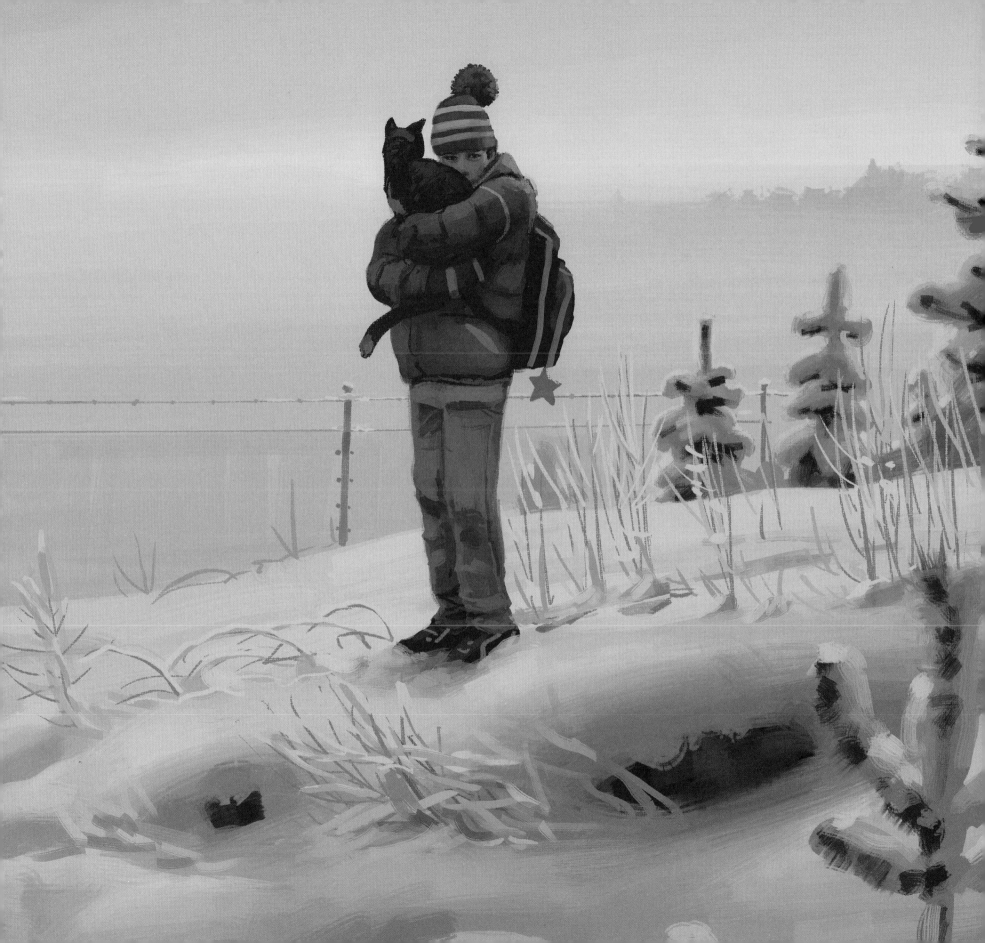

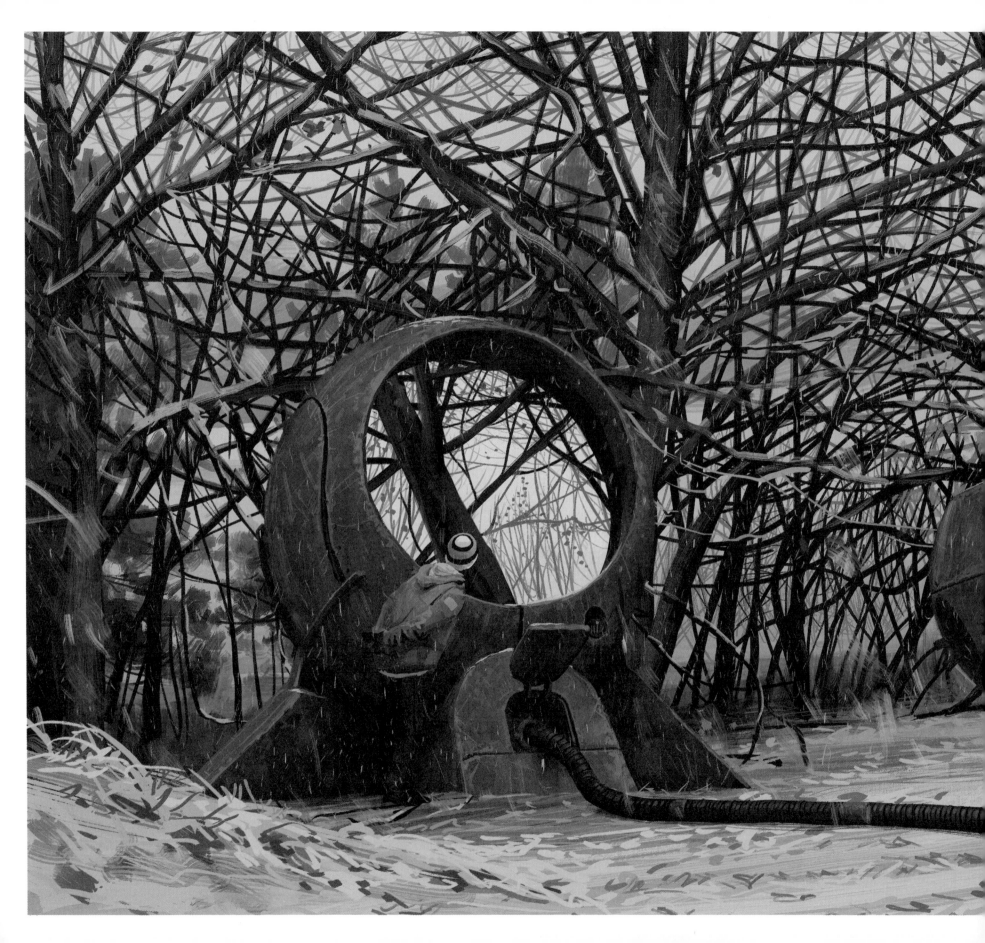

JURY-RIGGING

Two huge iron spheres stood in the garden behind Stefan's house. They gaped emptily and looked like giant cement mixers. But Stefan claimed that they were fully functional "Weismann Portals," just like those that had been developed in the Loop. He had built them himself from parts that he had appropriated from the Clovers facility during the years he worked there. "They're the real thing," he had said. The last and most important part, the so-called Meitner Pendulum, he had retrieved from a strange dodecahedron that had appeared by Svartsjö after the flood. It must have been some sort of portable Gravitron—a field generator.

After much effort, Stefan had set up the spheres, installed the Meitner Pendulum, and powered them up. They seemed to work, and Stefan had tested the contraption by climbing high into a tree by one of the spheres and then throwing himself straight down into its opening. "It's a perfect, stable connection!" he'd said. He knew this because, instead of hitting the bottom of the sphere and breaking his legs, he had been catapulted from the opening on the other sphere, and had soared over his garden and landed in his neighbor's compost heap.

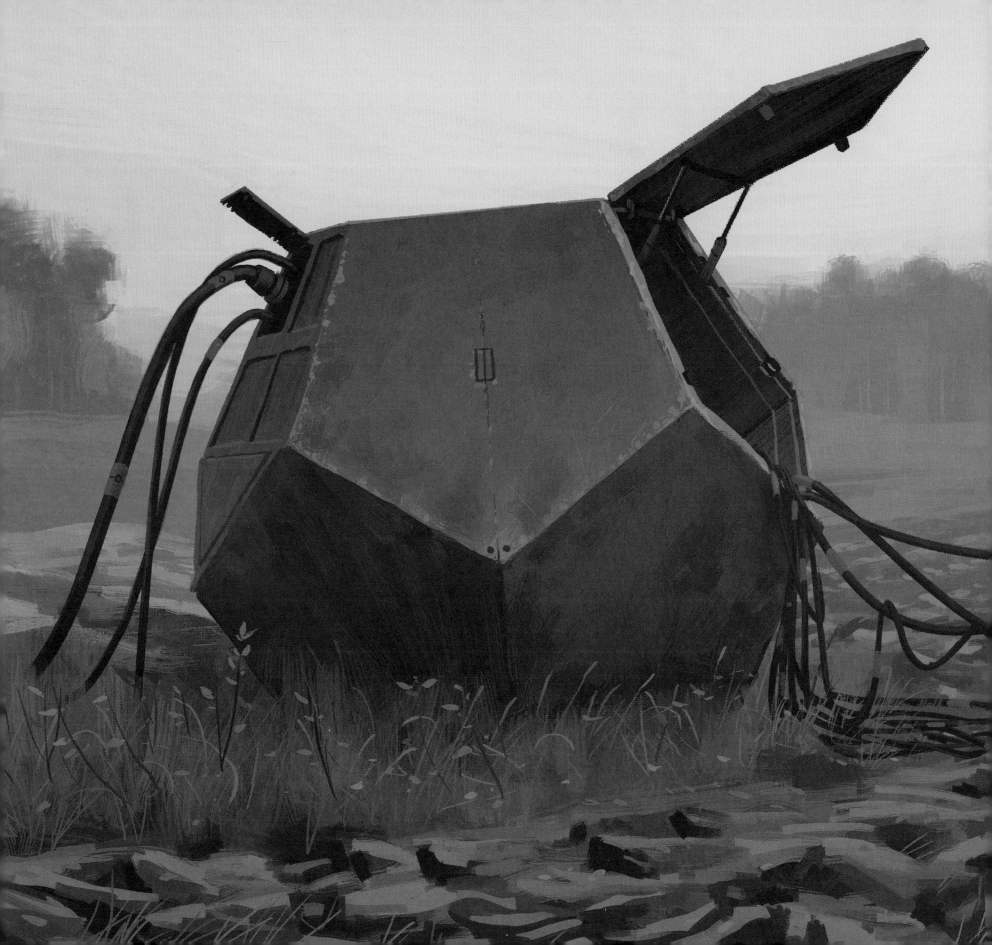

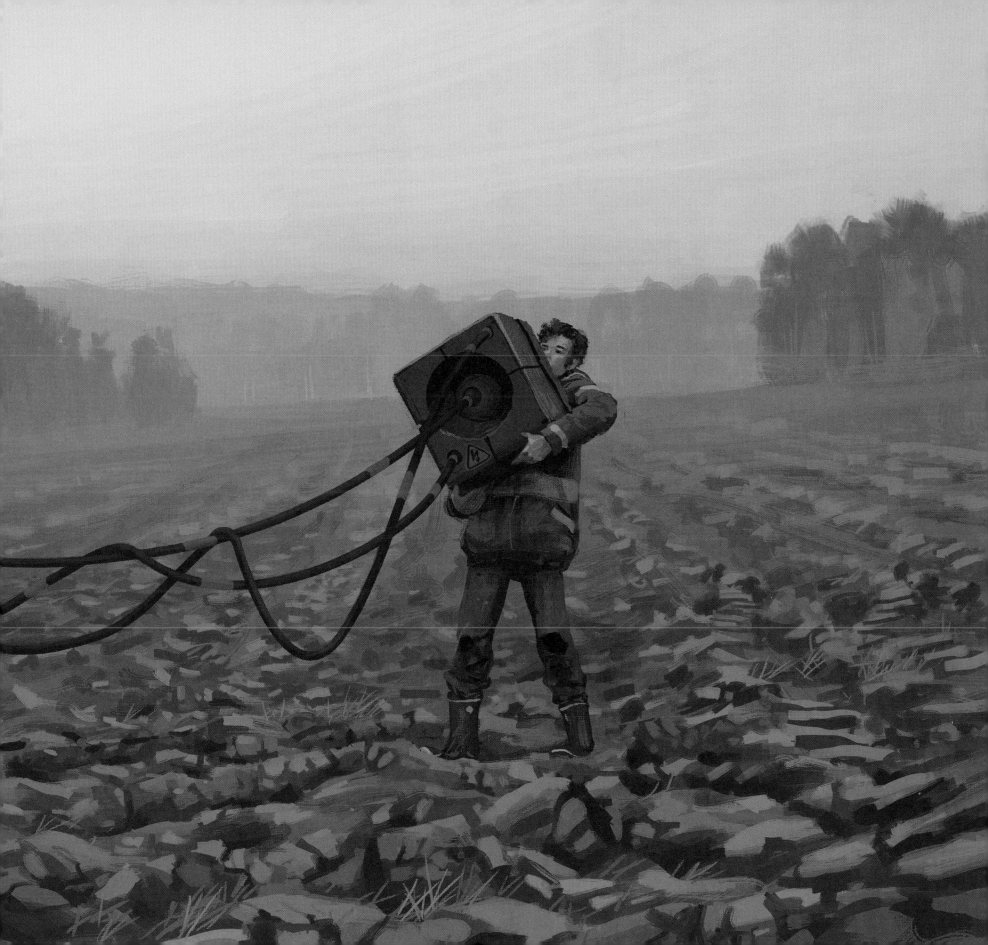

THE VAGABONDS

Scores of robots escaping the Russian AI pogroms moved into Sweden. Somehow, they had made their way across the ice to Färingsö and settled down in the outskirts of the forests, reeds, and deserted houses. They were called vagabonds. They were an odd group, and were fascinated by colorful fabric, complex patterns, fur, and feathers. Anything organic and soft was exotic and highly valuable to them, and they seemed to have developed some form of religious worship of biology and nature. We found their graffiti everywhere—on trees, rock faces, and concrete walls.

Many of the inhabitants of Mälarö disliked the vagabonds and were alarmed when they appeared in Berggården. A growing fear, and a discontent that nothing was being done, could be sensed in store checkout lines and in posts on bulletin boards.

Sometime in January of 1996, Jimmy Kraftling and his gang of miscreants had a fight with a vagabond down in the gravel pit, and Knuckles returned with three fingers missing from his right hand. It remained unclear whether the fingers had been removed by the vagabond or by one of the many homemade New Year's bombs they had been seen carrying down into the pit, but the inhabitants of Mälaröarna didn't care to find out. After the incident, the police were called and riot units gathered up any vagabonds they could find, after which the machines were sent to the recycling center in Nacka to be demolished.

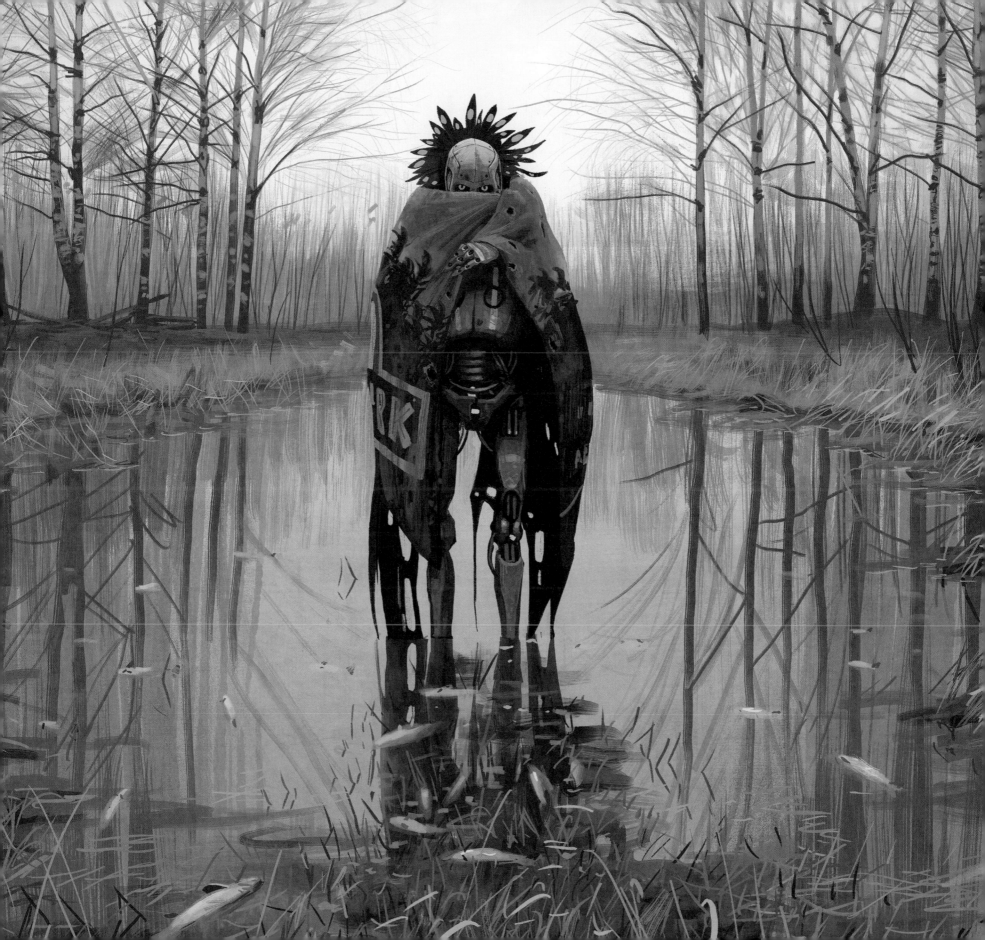

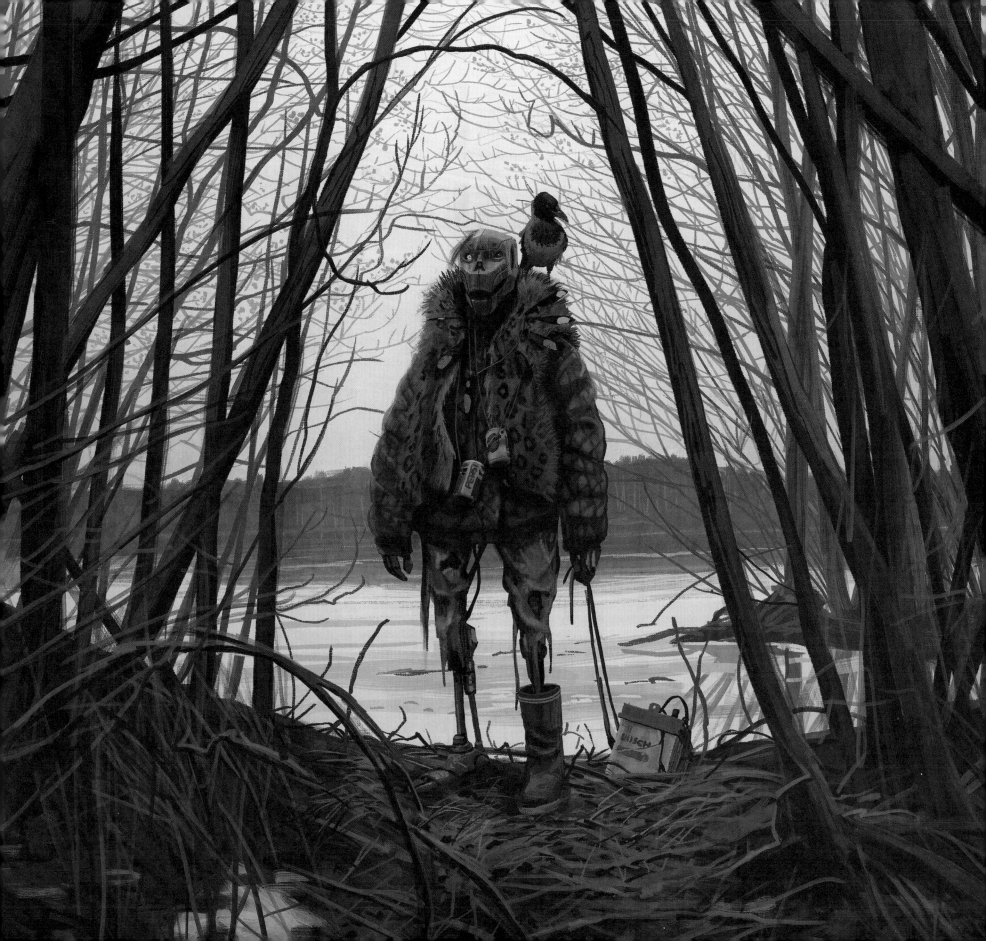

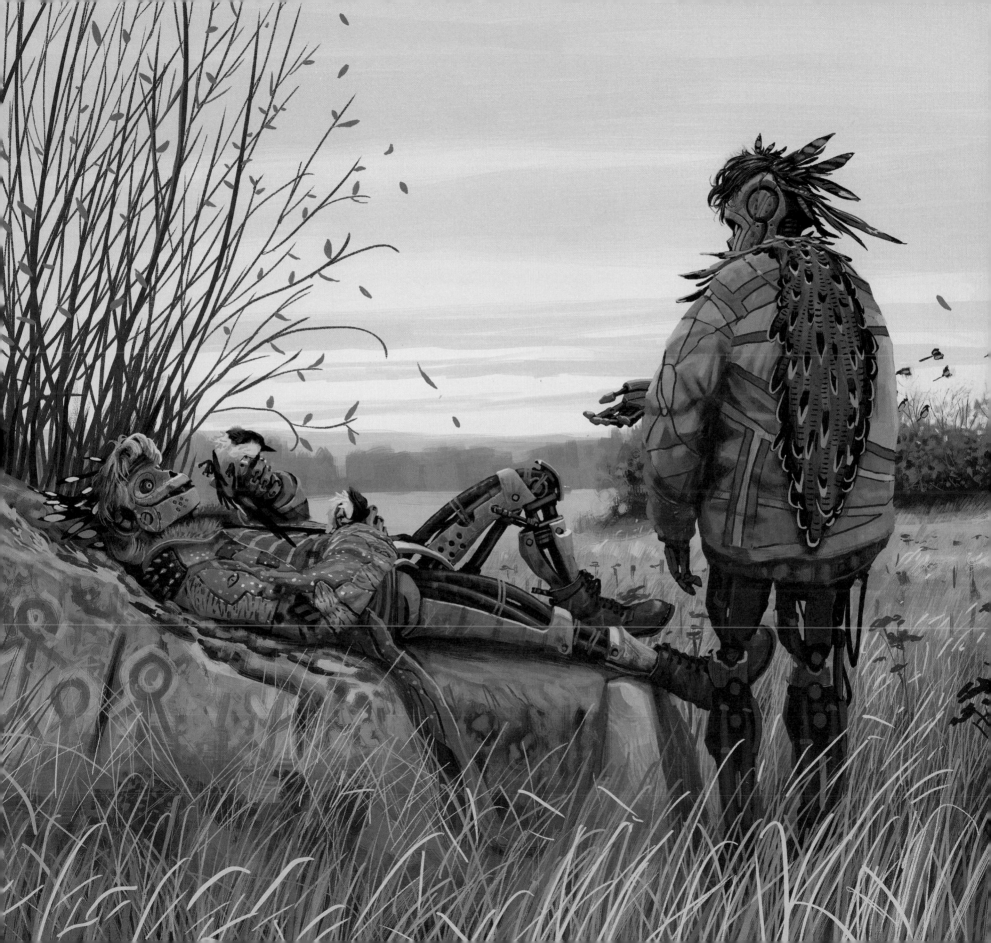

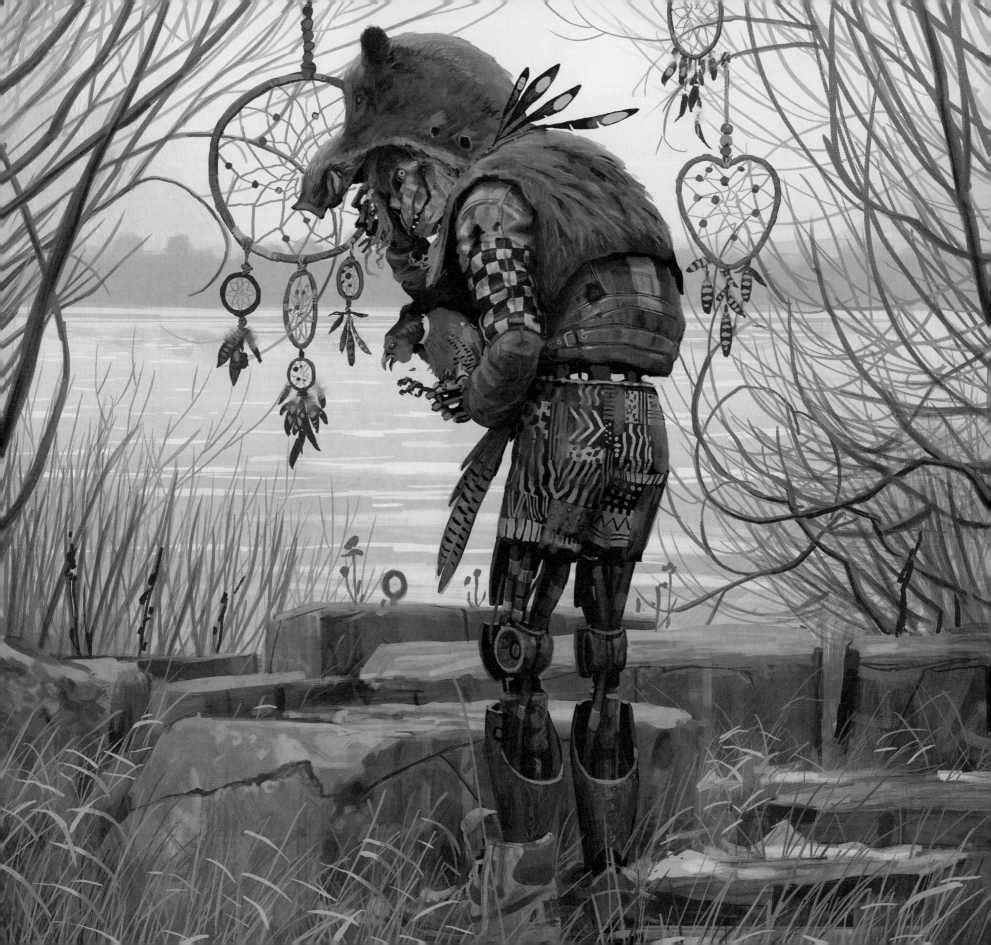

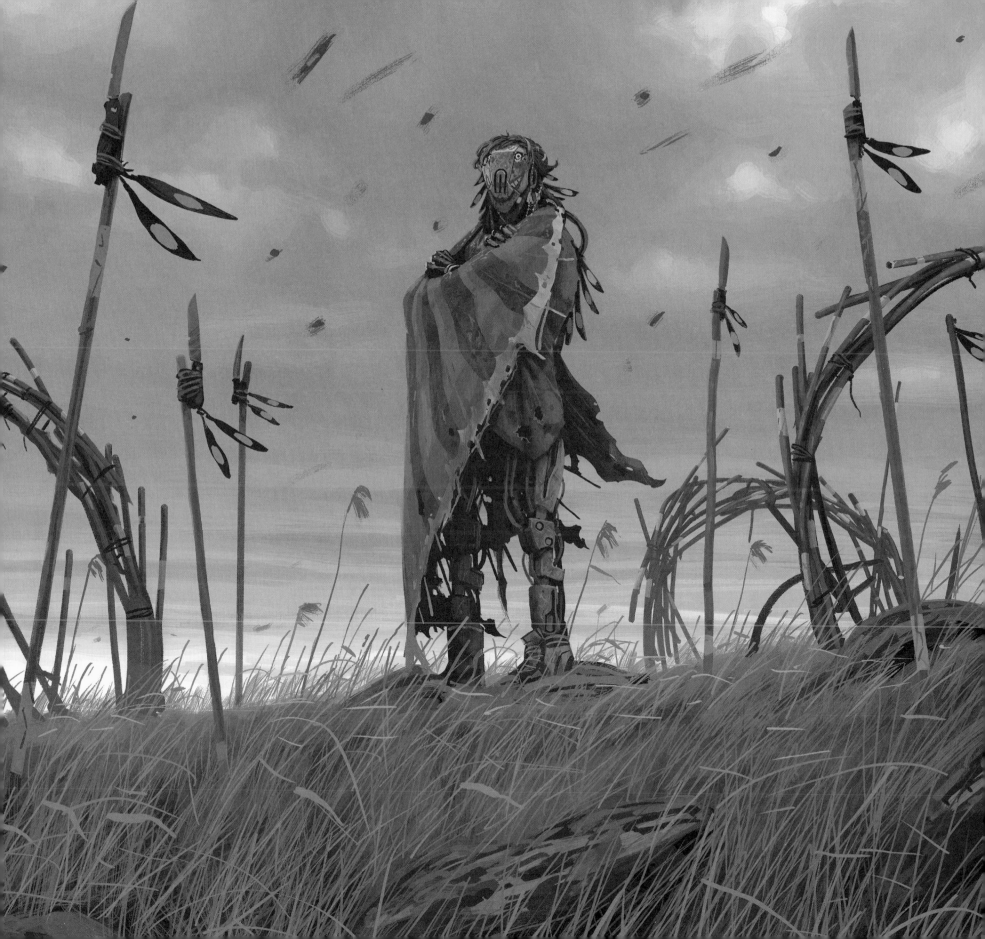

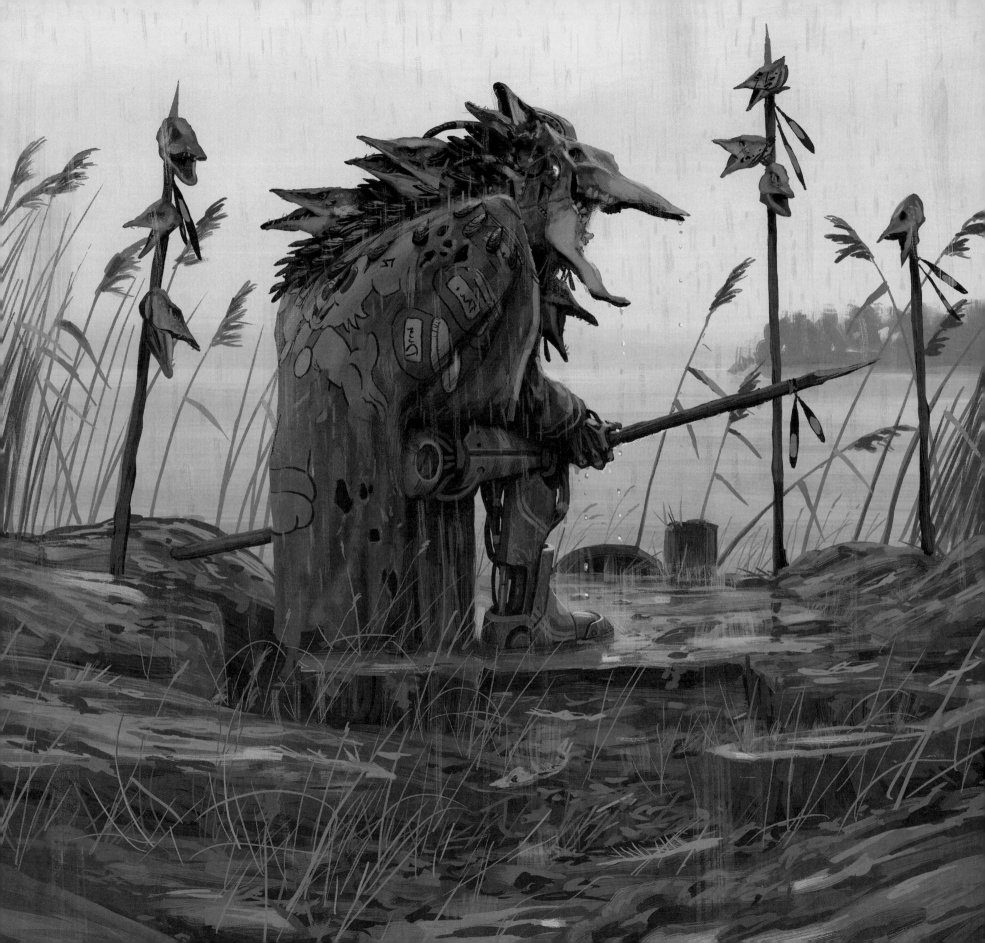

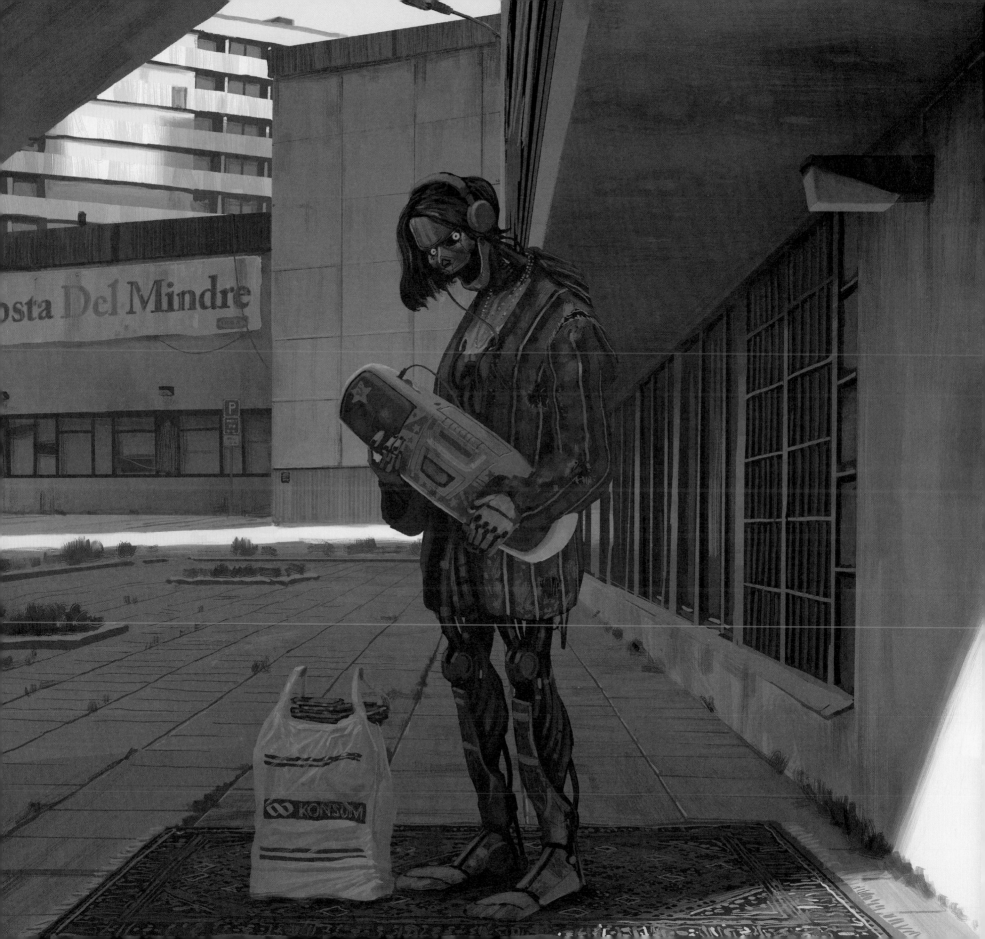

RIVER FLESH

The local community developed a fear of water. It was said that something from the flood had leaked out into the groundwater. It started as a rumor—I heard it first from Stefan, as one of his many crazy theories—but soon, otherwise-rational parents and teachers also decided that it was best not to drink water from the tap. Some said it was radioactive water from the core of the Loop, which had leaked after the flood. Others said it was something else, some form of bacteria that made people sick.

One night during dinner, Lars told us that they had received a call about an accident involving a Saab 900 in Österby. They had found the car overturned in a ditch, and the conditions inside the car were the most sickening thing that Lars Ribbing had seen during his fifteen years as a police officer. It had been impossible to discern if there were any human remains inside the car because the whole compartment was filled with unknown organic tissue. In Lars Ribbing's own words: "It looked like someone had squeezed a giant squid into the car." We all sat in silence, poking at our moussaka.

"It's the space water!" Stefan Eklöf said later that week, as I was waiting for him to find the 8-megabyte RAM that he had promised me. He was digging through a box filled with old junk at the same time as he gave me a comprehensive status report.

"The idea was to open a portal to the Soviet Union for the Americans during the Cold War, but it all went to hell. The Clovers facility only had one single purpose! It was to map Earth's exact position in the universe so they could establish a stable grid of coordinates. They had to know exactly where the Soviet Union was, in the cosmic sense—the problem was that Håkan, who was in charge of mathematics, mixed up some damn decimal points and suddenly they ended up on 51 Pegasi B instead, 53 light years off. It's an ocean planet, it seems. And now some damn space bacteria are on the loose. They sure are busy now, the Krafta people."

5 kV x3,000 5μm KRFTALABS 20/FEB/

THE CULTURE

"Your mother and I don't like that you spend time on your own at the Astronomer's house. Something isn't right in his head," Lars finally said. After that one time that Stefan showed me his "culture," as he called it, I was prepared to agree with Lars. Three bathtubs stood in Stefan's basement, and a strange collection of seemingly random items—cans, reel-to-reels, cameras, and so on—was submerged in the water.

"It's something involving the combination of plastic and metal!" Stefan said. He picked up a very small pin from the water using long fire tongs, and he inspected it closely. He muttered approvingly at some microscopic detail before returning it to the tub.

"Come here and look."

Stefan opened the door to his garage. Inside the garage, he had the most bizarre collection of objects I have ever seen.

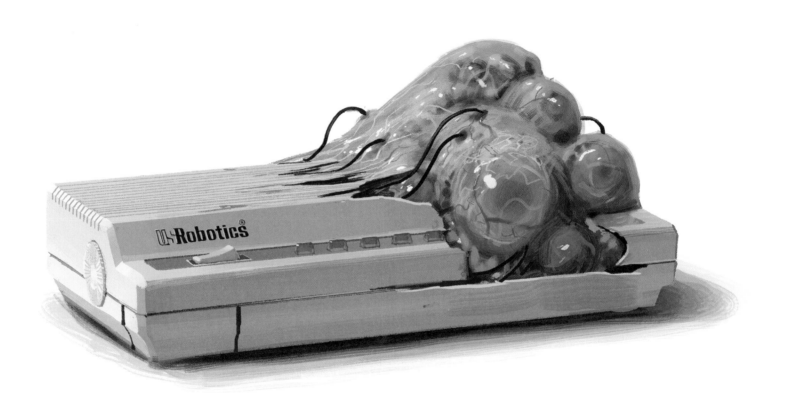

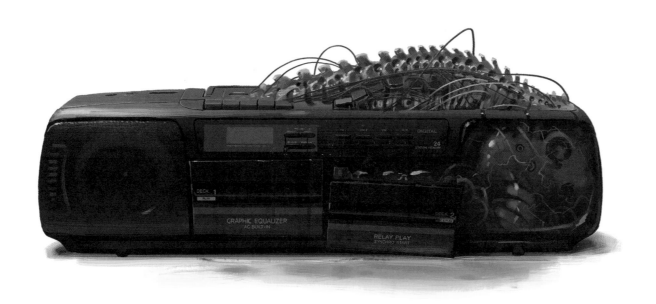

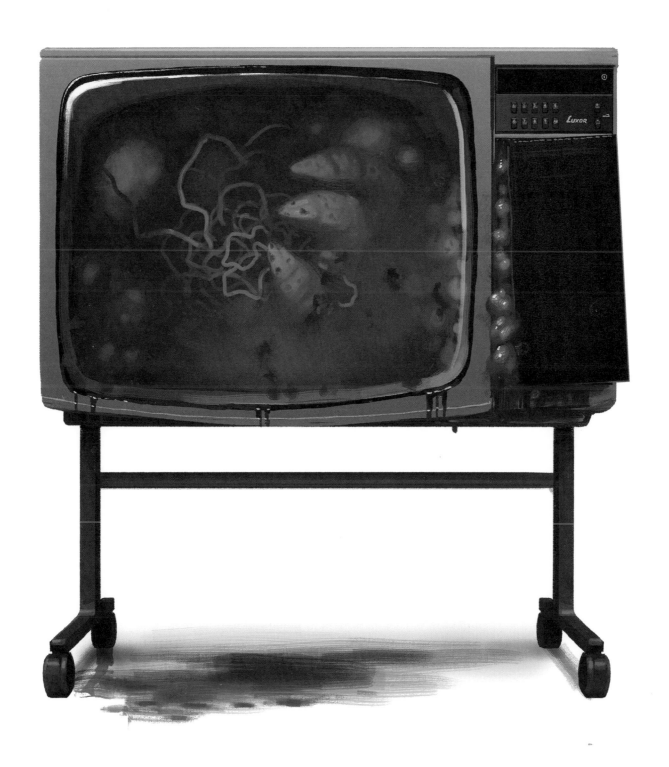

MACHINE CANCER

"Now would be the time to rob the bank in Hägerstalund," Lars said. The entire Ekerö police force was busy handling the side effects of the so-called Machine Cancer. The utility machines on northern Färingsö began acting up. They were impossible to control and roamed around like sick animals. Soon odd growths were found on their joints and limbs, and the police were busy around the clock handling the damage wrought by the errant machines. An endless procession of Krafta salvage vehicles carried away defunct robots, and there were constant traffic jams on the road to and from Färingsö.

They said it was because of the neural grease. All balanced machines and autonomous robots were continuously lubricated with a form of wax that saturated the artificial nervous system and enhanced conductivity in the nerve fibers. Krafta had recently begun using a new, experimental neural grease, and it was supposed to be this new grease that caused an uncontrollable growth of nerve fibers that in turn made the machines run amok and finally break down.

Of course, all of this was nonsense according to the Astronomer.

"It's crystal clear! Our visitors from 51 Pegasi B have found the perfect hosts!"

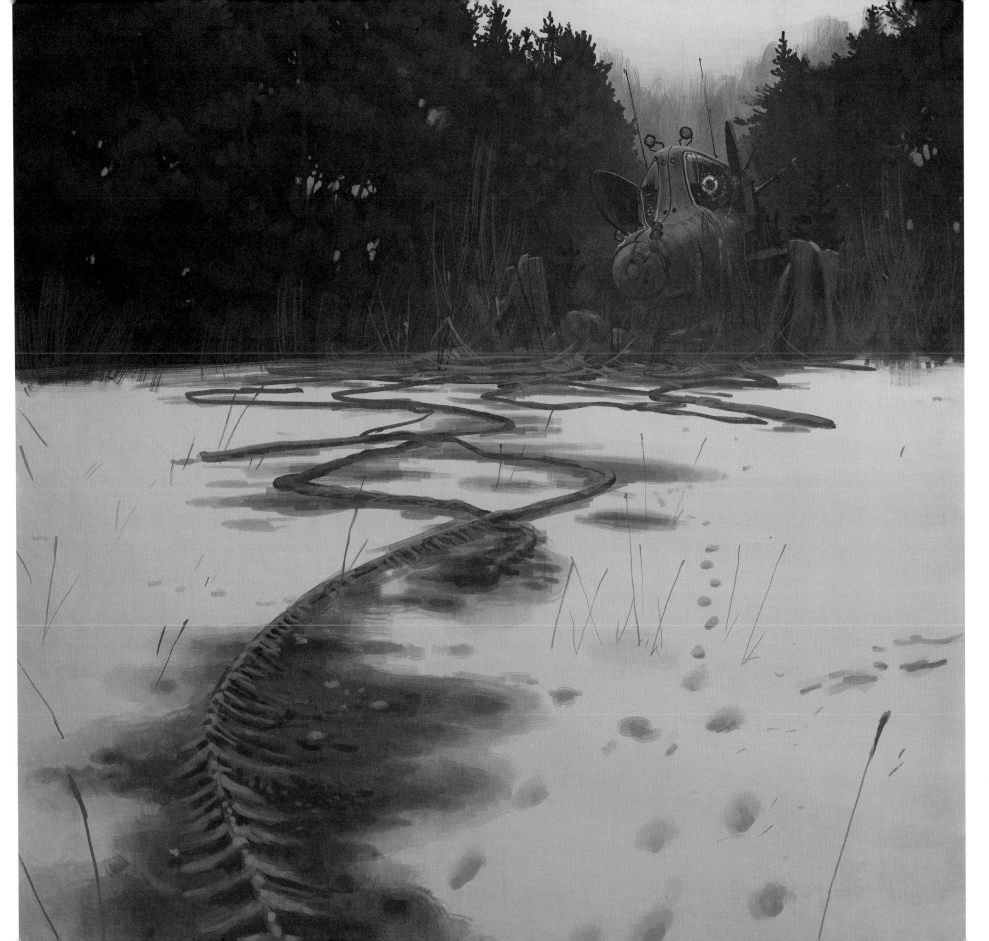

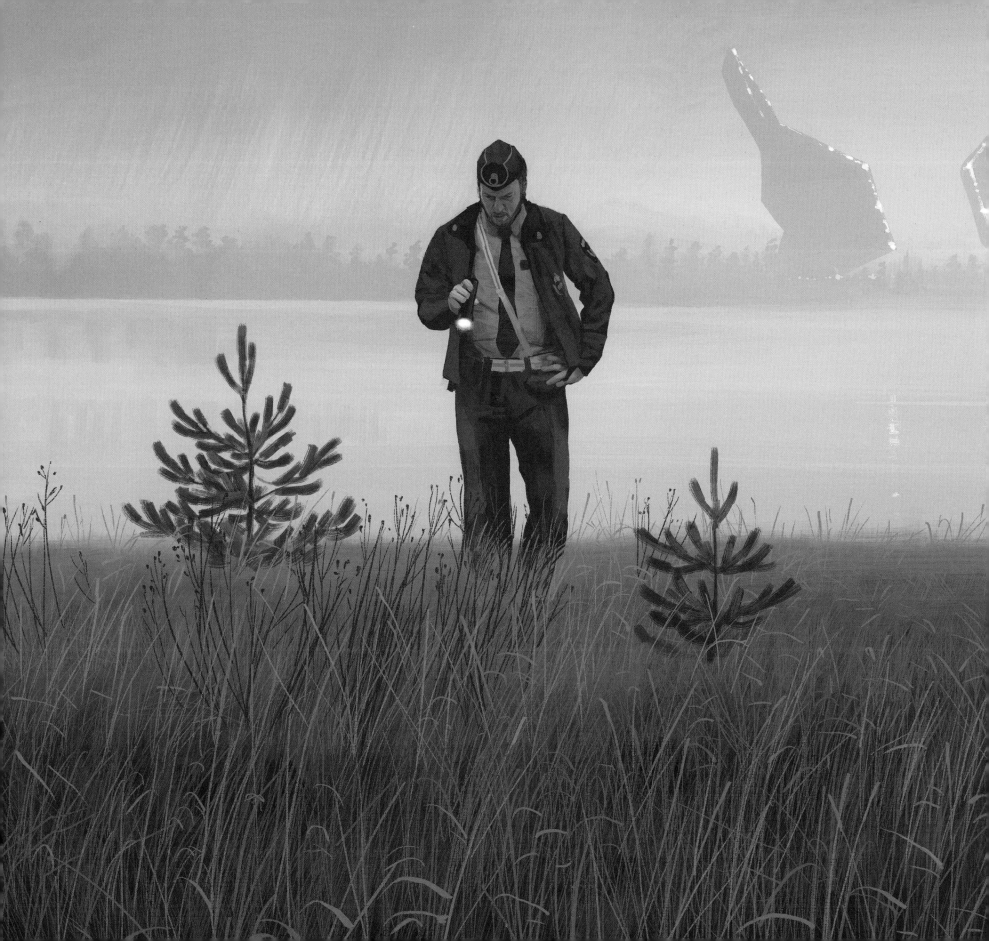

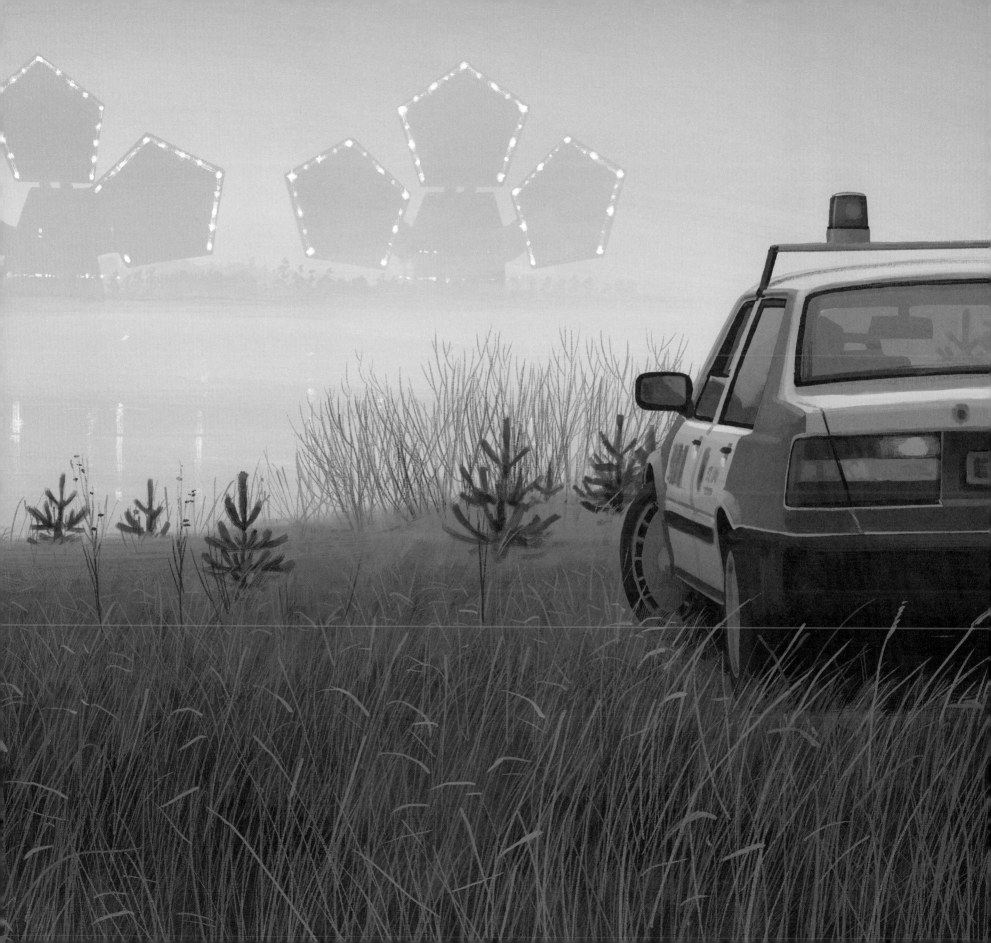

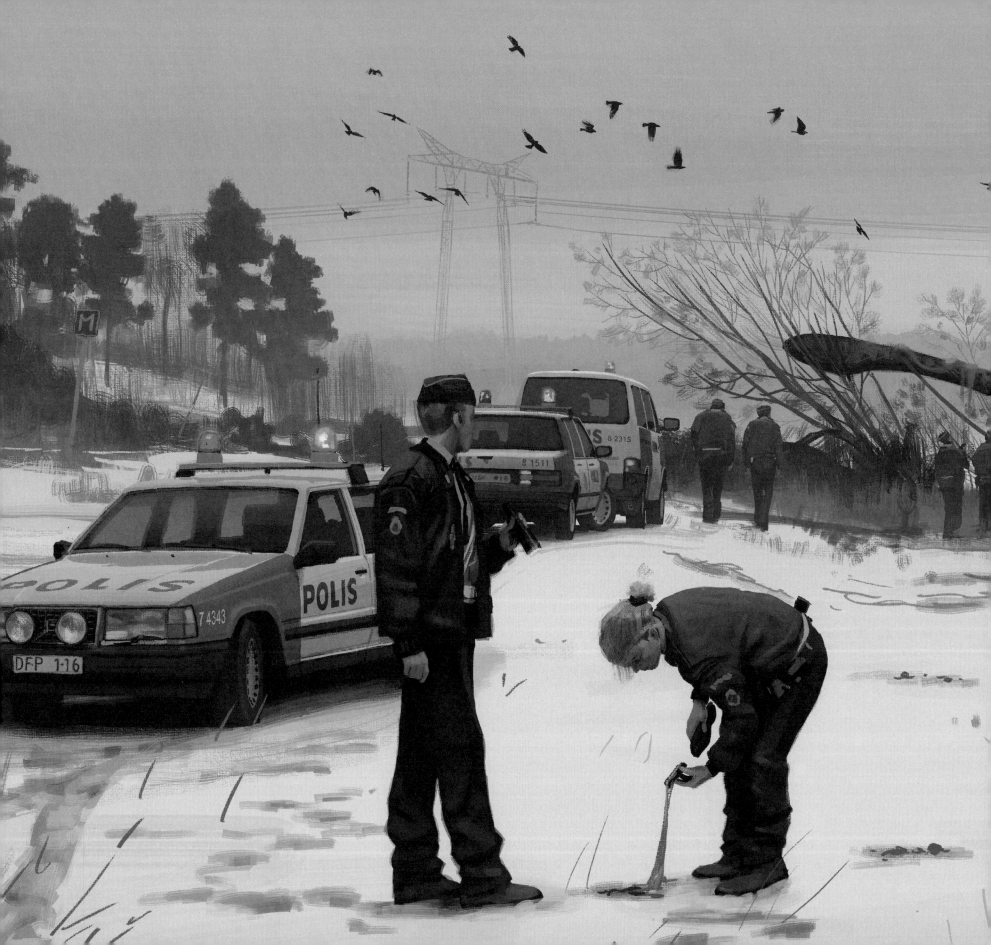

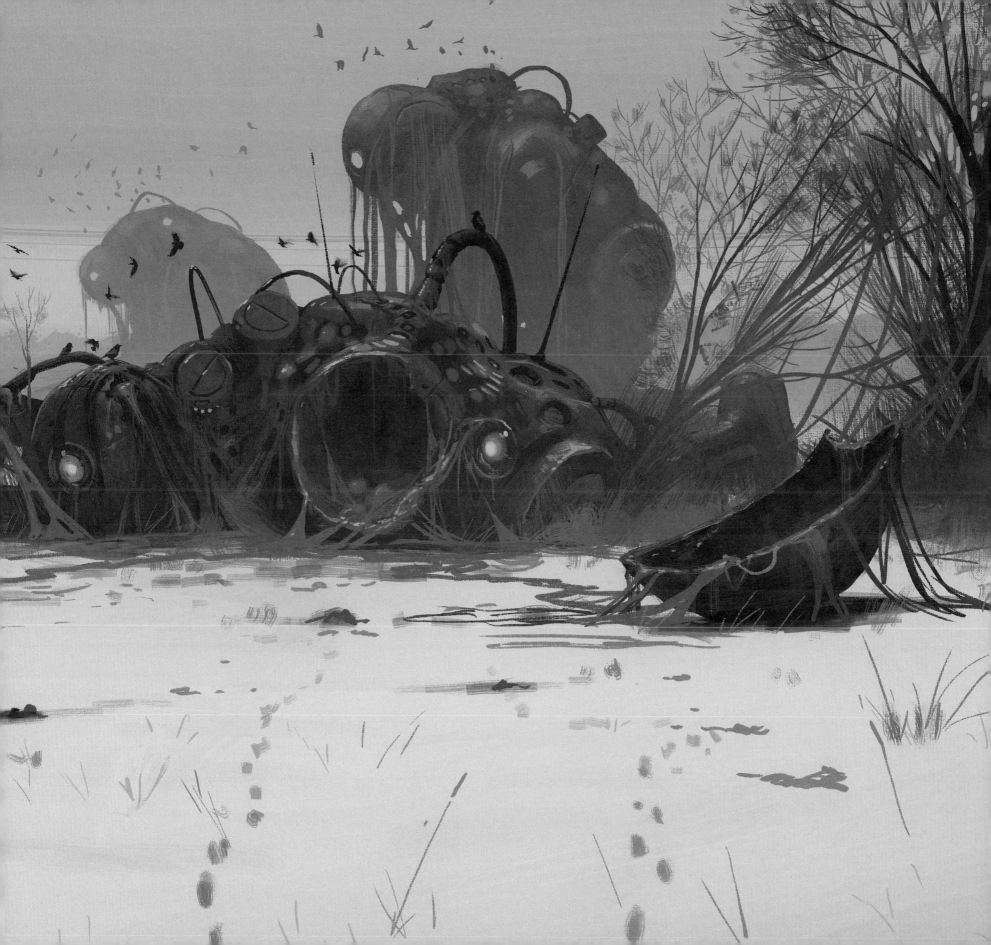

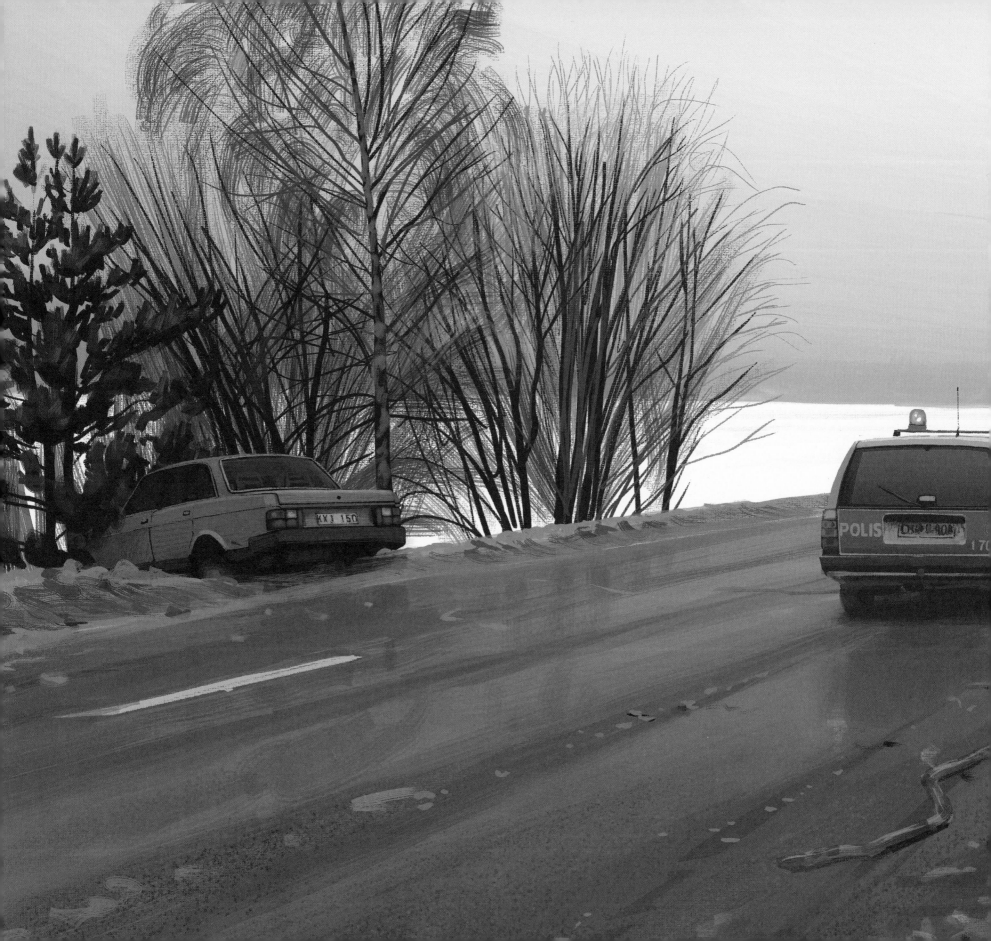

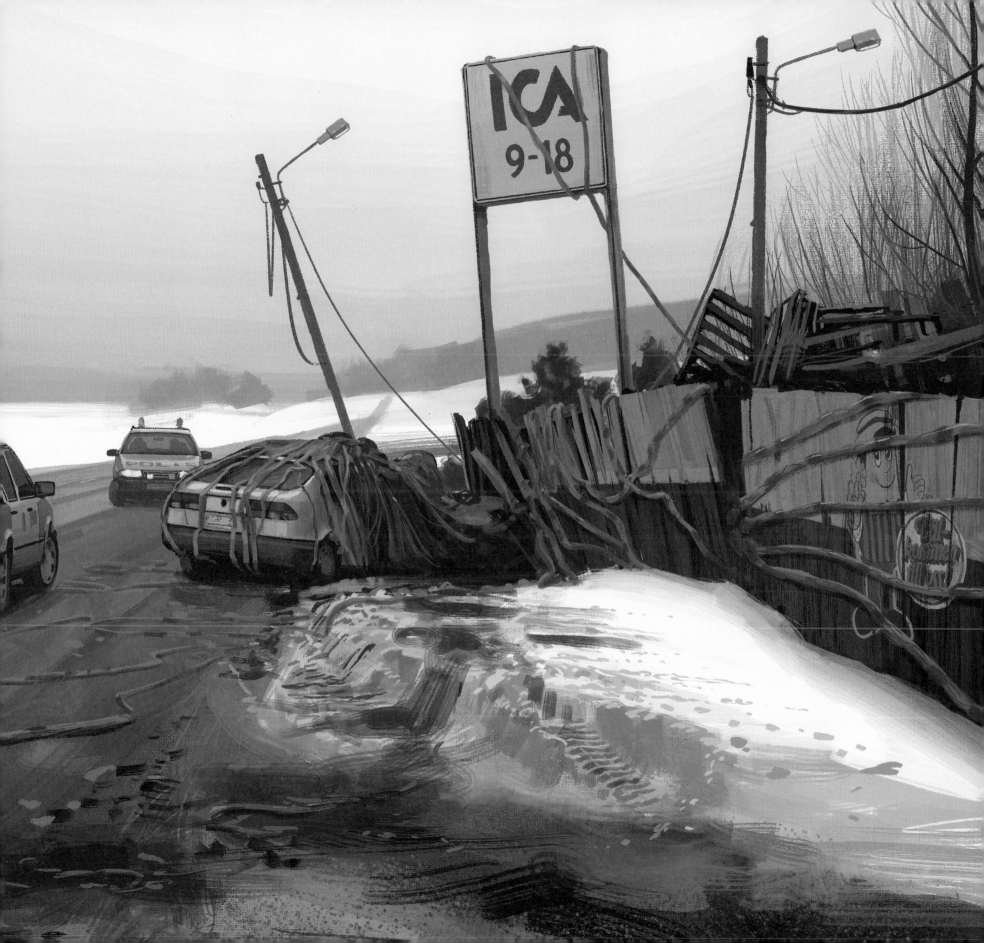

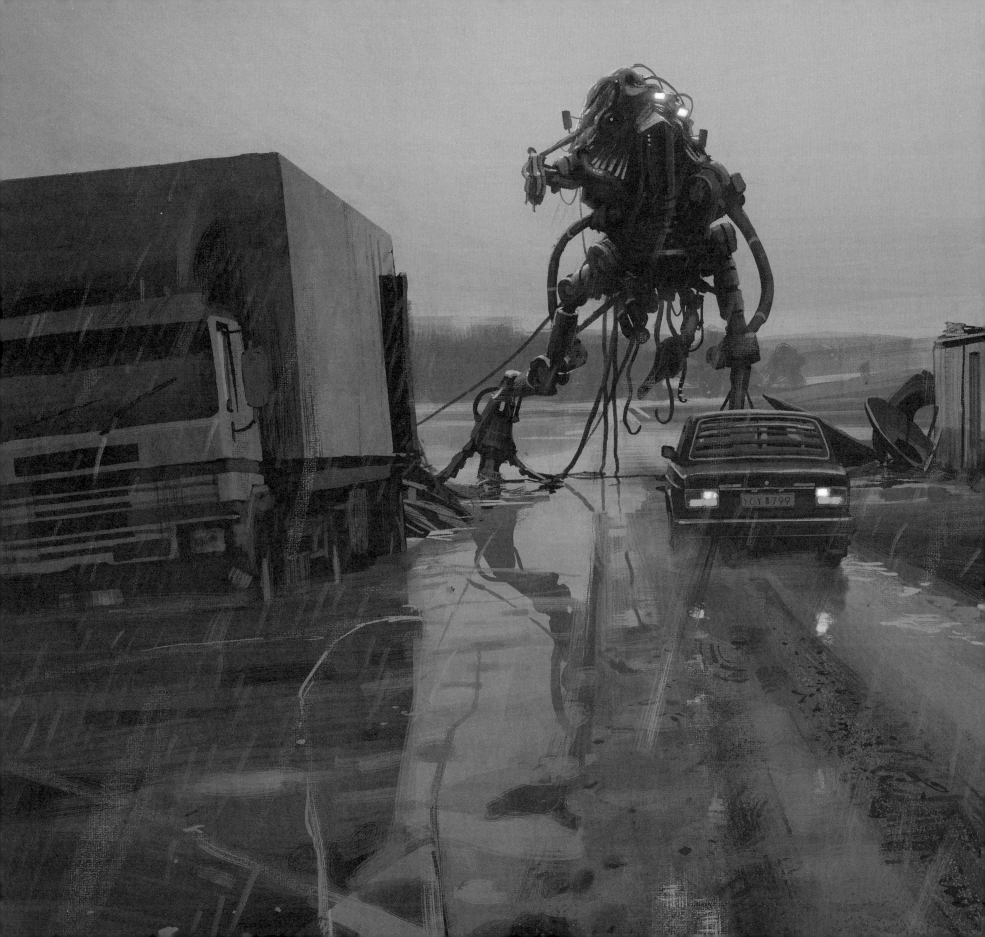

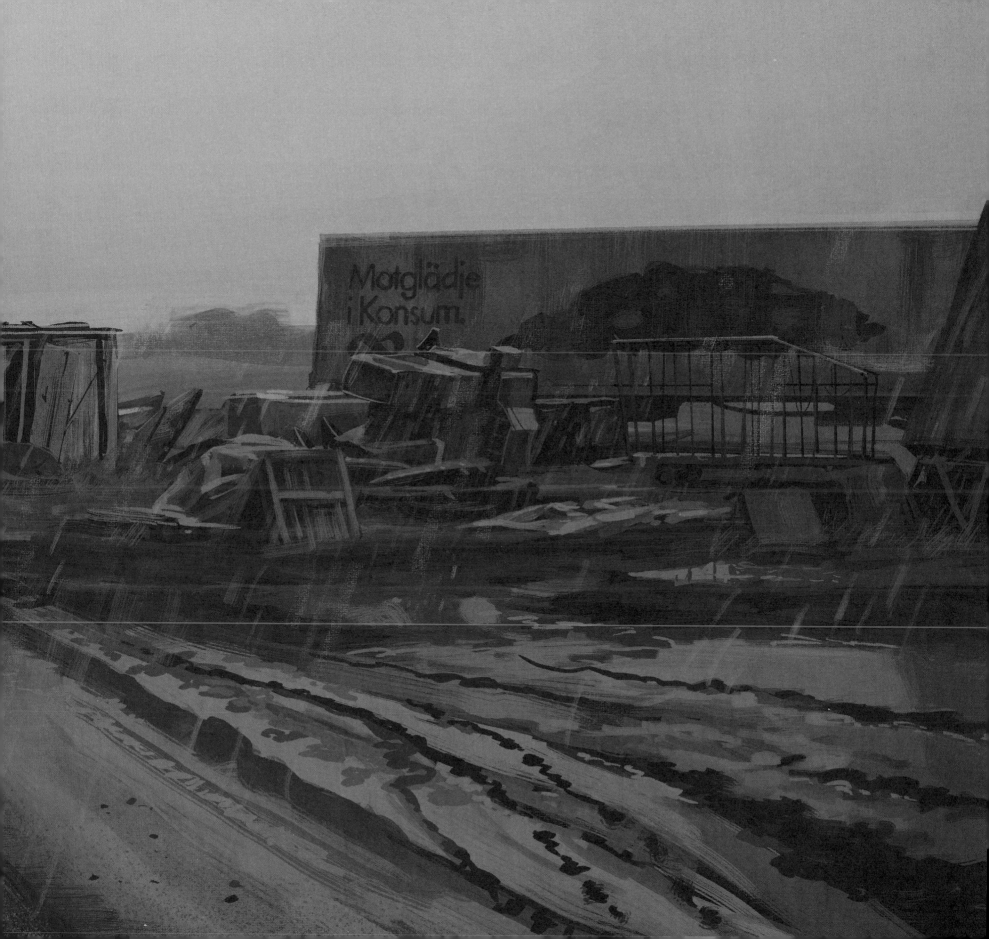

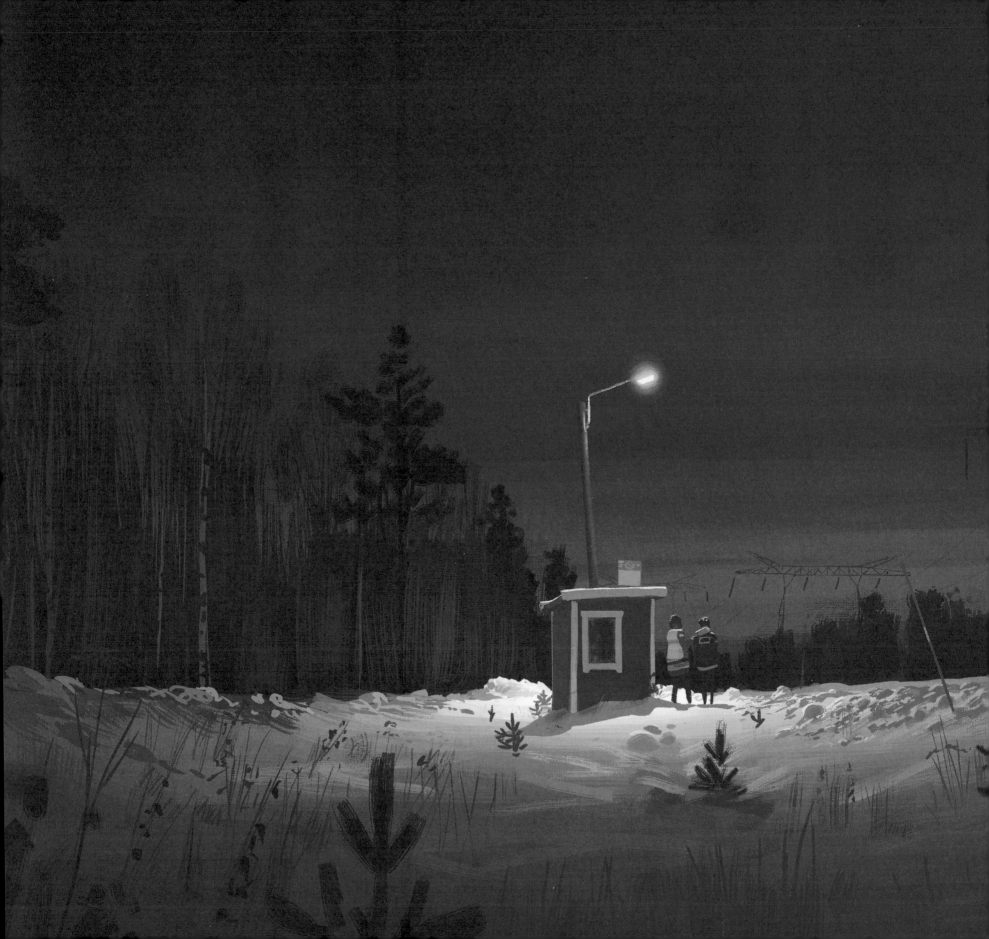

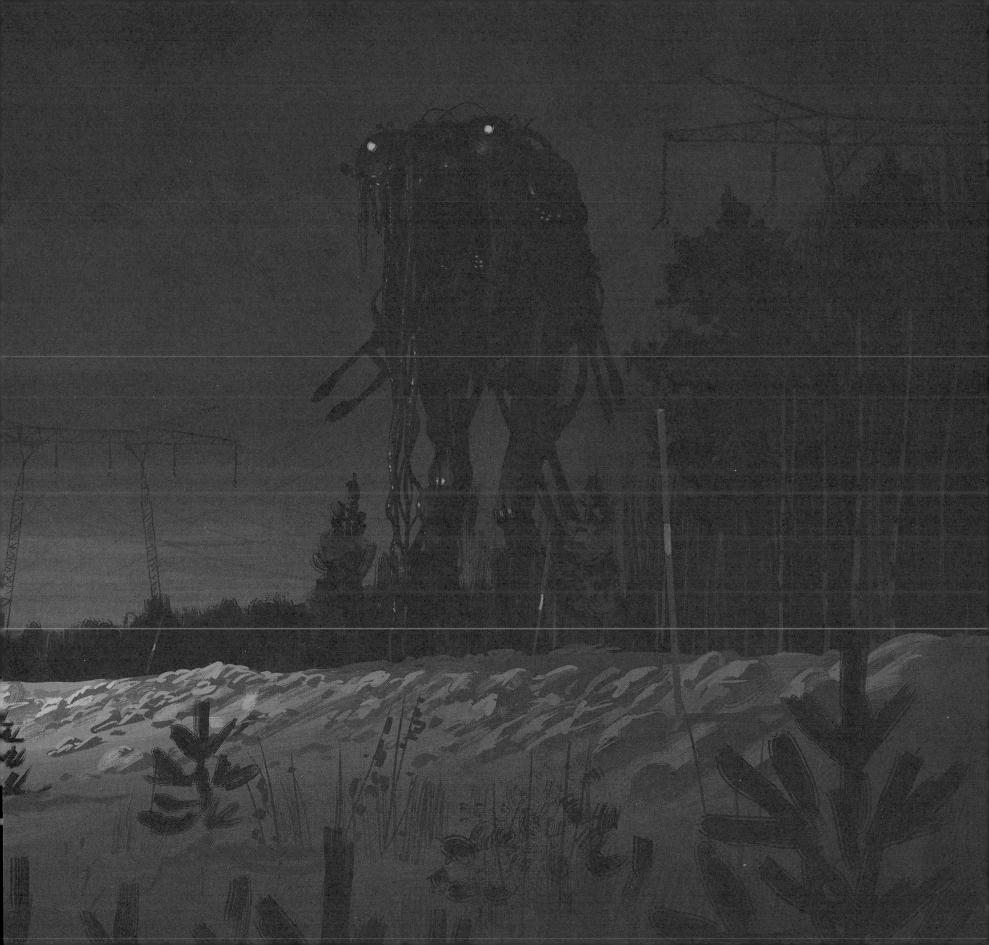

SOCKARBY QUARRY

Between Sånga and Berggården lay Sockarby Quarry, a gaping wound in the otherwise picturesque farming landscape of Mälaröarna. Ruby-colored ore had been mined here up until the 1950s, and the huge Karman Färna blast furnaces had long since polluted the ground with slag products and turned the area into a stinking, deforested wasteland.

An ancient parish house sat by the slopes of the slag heaps. It had originally been erected to offer the coughing miners and their dust-filled lungs some divine guidance in life. Now it was decrepit and falling apart, and everyone was surprised when a priest and his two children moved into the house in early 1997.

The priest was named Paveli Wuolo, but he quickly got the nickname "The TV," because of the enormous square glasses he wore (there was speculation that he could receive cable channels on them). Paveli Wuolo's grand plan was to renovate the parish house and bring GOD back to the inhabitants of Berggården. The house smelled weird; it had a sharp odor of soap, as if someone was constantly trying to scrub all of the old miners' anguish out of the walls.

Paveli himself was a fountain of joy. We often saw him up on some scaffolding, happily singing with a brush in one hand and waving it around like a conductor in front of the facade of the parish house. When he saw us walking up the driveway, he jumped down from the scaffolding, extended his long arms, and yelled, "MY ANGELS!" He embraced Lo and me in a long, boa constrictor–like hug (Paveli was huge: at least six foot ten). We would give polite answers to his questions about how we were doing and what our parents were up to, but of course we didn't go there to meet Father Wuolo. The reason we came to the parish house was that the Forum's best robot hacker lived in the basement: Paveli Wuolo's godless daughter, Johanna, also known as S0ulFuck3r.

S0ulFuck3r was a legend, having stolen hundreds of classified documents from Krafta servers by using an old STM laptop to hot-wire a Cormorant 226. She claimed that she had used a Tamagotchi and fishing line to lure the quadruped robot into one of the cramped positronic exhaust wells, where it got stuck, and thus the Cormorant's dangerous pincer arm was rendered harmless.

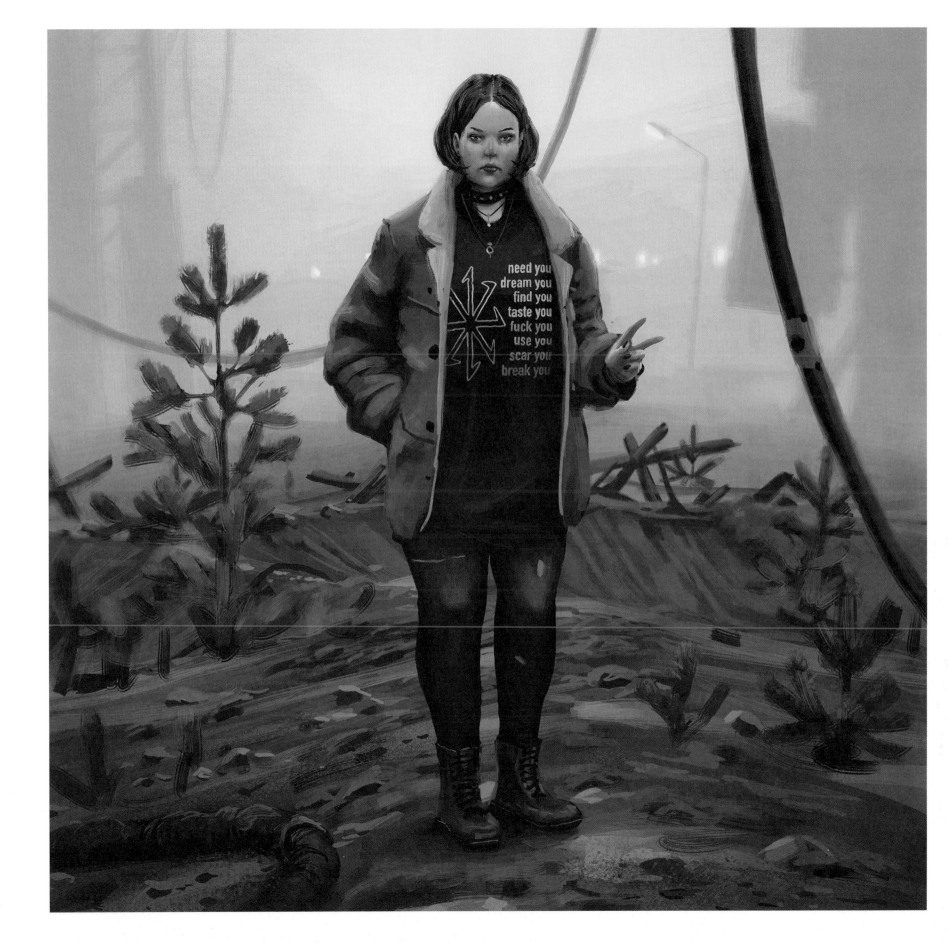

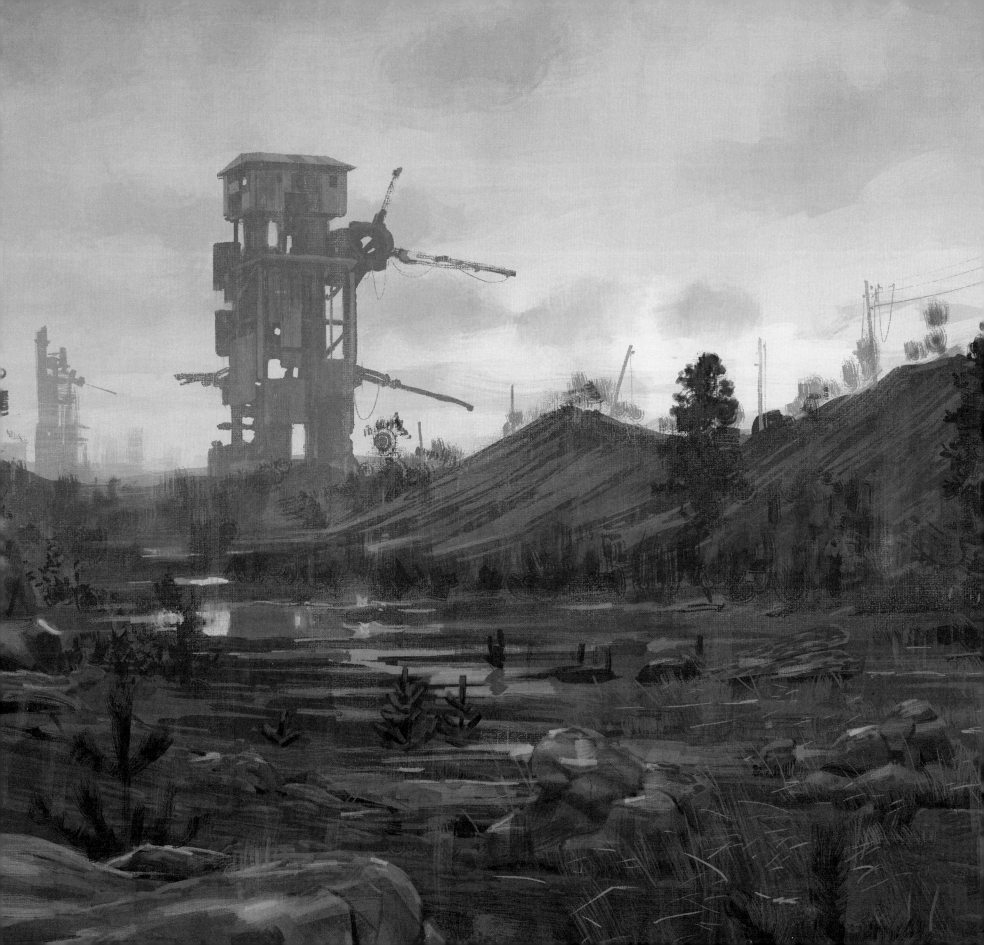

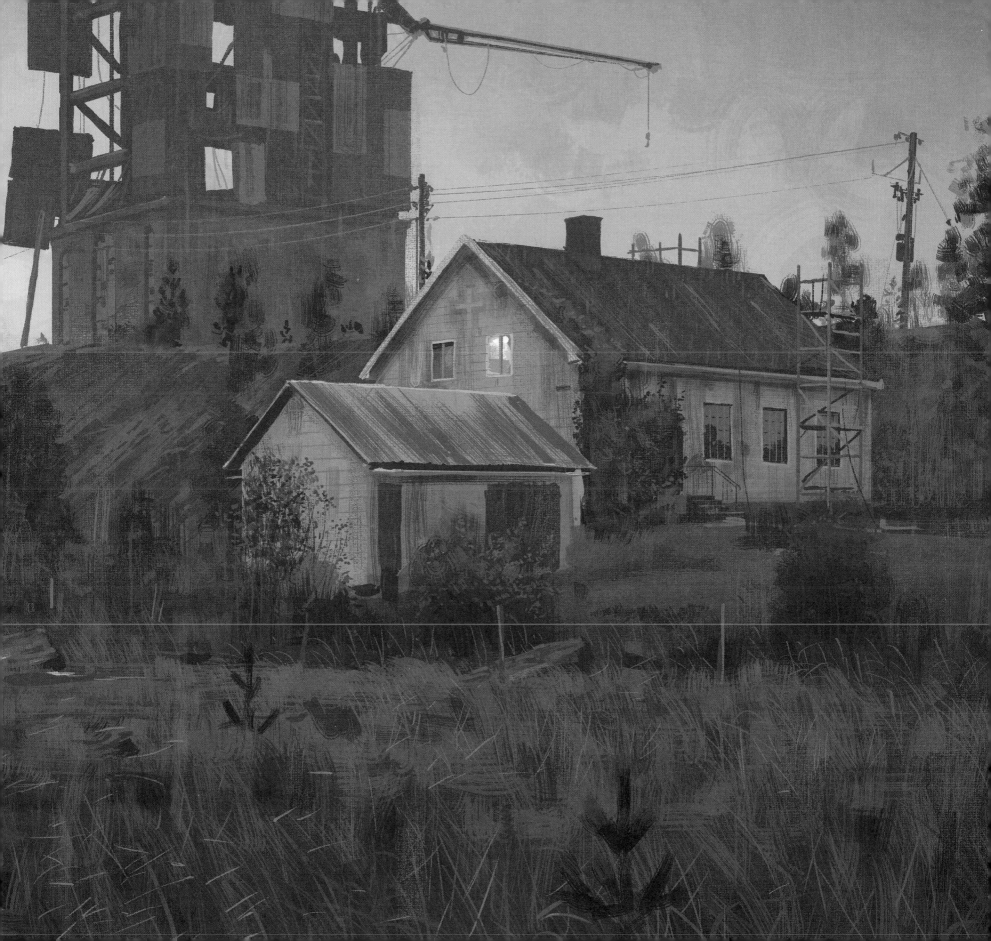

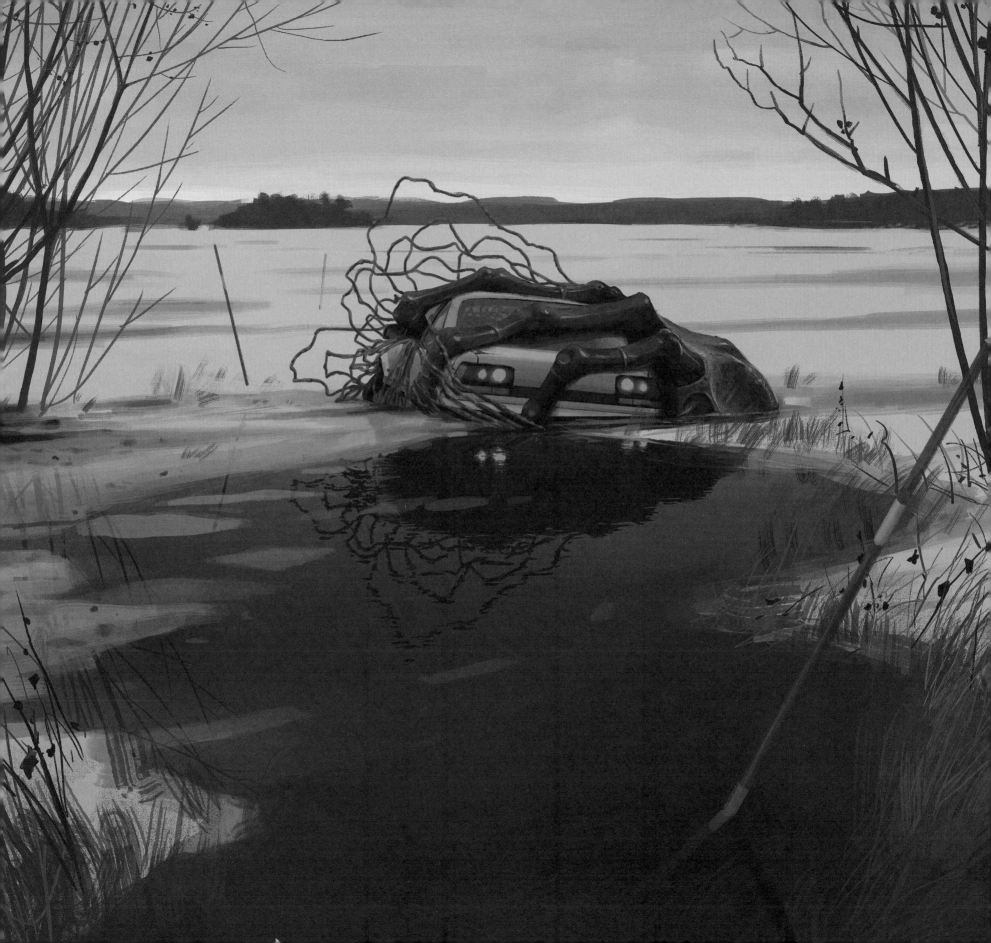

A BEAUTIFUL, BEAUTIFUL BUTTERFLY

There wasn't a single centimeter of wallpaper visible in Anders Näslund's room. The walls were completely covered by posters. Body parts, demons, space ships, zombies, flying saucers, and betentacled monsters created a gaudy patchwork behind Anders's pimpled face as he told us the story in a breaking teenage voice. His uncle had narrowly avoided being swallowed alive when a "Tellus/Pegasi drone" attacked his car out on northern Färingsö. Anders claimed that this was the result of the pregnancies he had observed in the robots infected by "Machine Cancer." Anders clearly gestured the quotation marks around the words.

It was hard to take Anders seriously, because he said so many strange things. The year before, he had told us that the enemies in *Doom* actually exited the game to collect ammunition from another game on the computer. When he later told us that the Renault Twingo that had been found wrecked by Hilleshög had in fact been massacred by enormous killer grubs, we weren't really scared, especially since almost one entire wall of his room was covered by a gigantic *Tremors 2* poster.

But Anders wasn't the only one talking about monsters and conspiracies after the flood. The Berggården school was abuzz with rumors about what was really going on in the evacuation zone, and everyone seemed to have their own favorite version of the truth. Some said that something which made insects grow had leaked out of the Gravitron, and others said that the particle accelerator had opened a black hole, out of which nameless horrors from a parallel reality spewed forth.

Johanna showed us a document. She claimed it was a fax from the biological institution at the university in Lund. According to her, the fax outlined an analysis of water samples from the flood in northern Färingsö. Understanding the scientific jargon was next to impossible, but there was one phrase in the document that made us very excited: an "abnormal biological component" was mentioned in the summary. Suddenly, avoiding tap water seemed very reasonable.

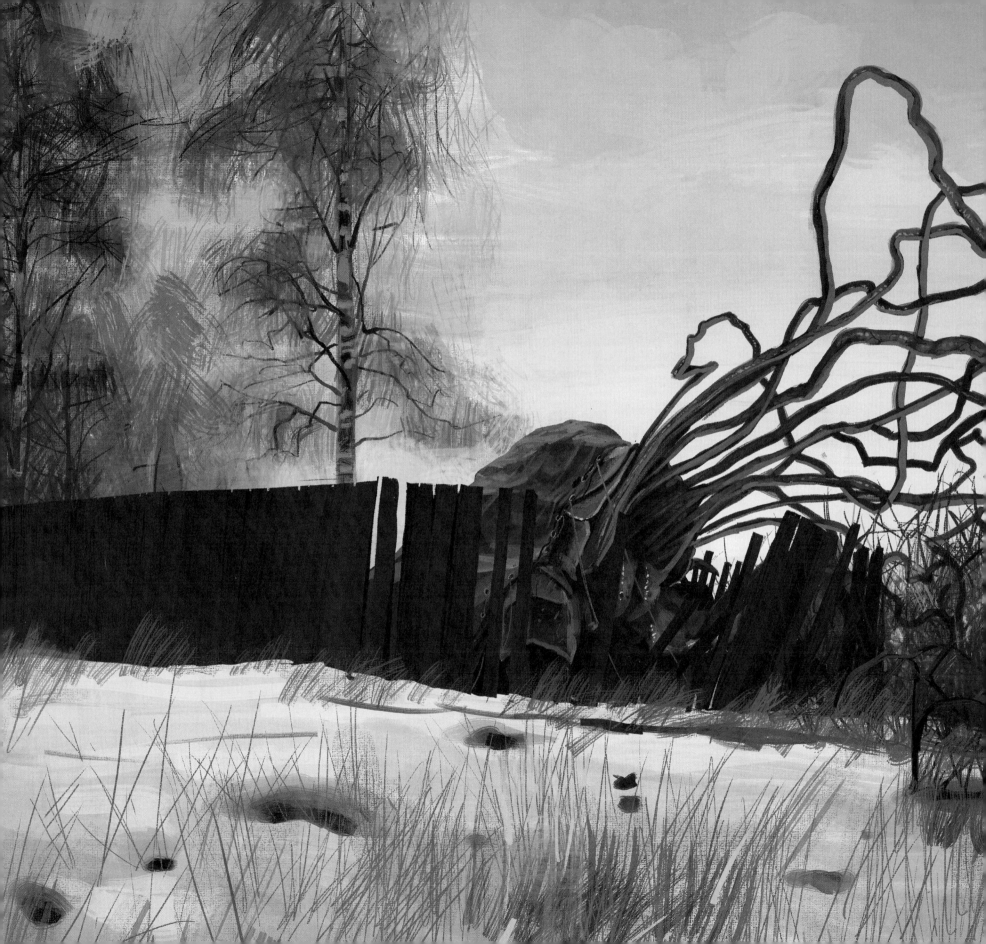

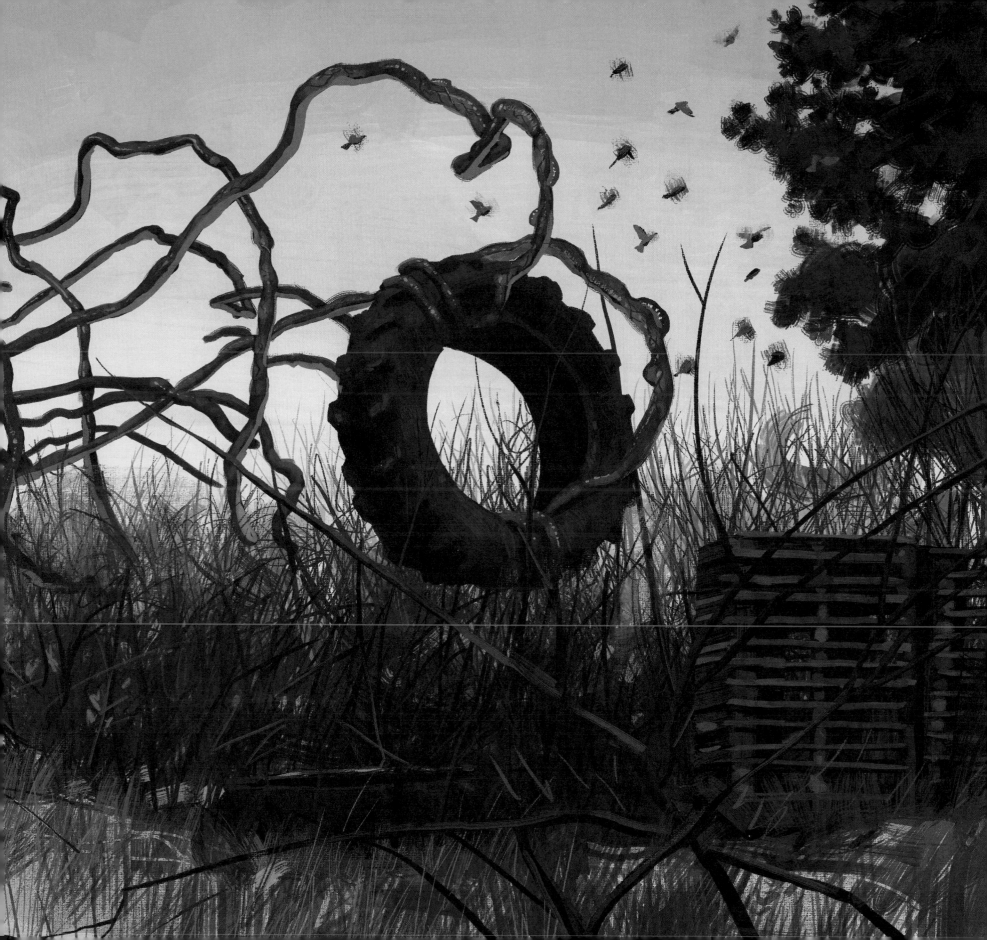

UNIVERSITY OF GOTHENBURG
DEPARTMENT OF CHEMISTRY AND
MOLECULAR BIOLOGY

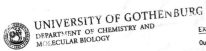

EXPERT OPINION

Our date
1996-07-08

Your date

Diary number
155/96

Your number

sign
96-07-08
LUNDBERGSLABORATORIET

EMPLOYER

Krafta Group ASA

SAMPLE MATERIAL

Water samples from the Loop facility, Färingsö, Ekerö kommun. See appendix 05A.

PURPOSE

Analysis of water samples has been requested via telephone, to ascertain if there are any traces of toxic, radioactive or otherwise insanitary components.

PROCESSING

Analysis has been performed by first chemist Anton Rehnberg, chemist Lena Stålberg and biologist Lotta Andersson.

METHODOLOGY, ANALYSIS AND RESULTS

Both quantitative and qualitative samples were collected in tubes from several different locations (see appendix 5) from a depth varying between approx 0.2 meters and 5 meters, and preserved with Lugol's solution. A plankton sample was taken using a 0.5 micron sieve and preserved with formalin.

Upon examining the samples it was determined that the water had an abnormally high salinity for the geographical area in question, at levels consistent with serwater. In fact, chemical analysis also revealed a composition very similar to what is normally found in seawater. Further analysis is required to determine if this is an artificial composition inherent to the very special environment where the samples were taken (a flooded particle accelerator) or if this is really seawater. Considering these initial samples, it is highly unlikely that the water is from the Baltic Sea.

Our major finding is undoubtedly the deviant biological components discovered during analysis of the plankton samples. Apart from several common species such as *Emiliana huxleyi*, several species of the *Chrysochromulina* genus, a number of phytoplankton were also discovered. We have so far been unable to classify these plankton. They exhibit several morphological similarities with diatoms but differ in the number of membranes in the chloroplasts as well as several yet unidentified shell structures. See appendix 6 for a detailed analysis of the plankton samples. Samples have been sent to the Ecosystems Center at the Marine Biological Laboratory in Massachusetts, USA, for further analysis.

Professor Jan-Ove Åkerlund
Laboratory director

Postadress
Box 462
405 30 Göteborg

Besöksadress
Medicinaregatan 9 C

Telefon
031 - 786 22 32

Telefax
031 - 786 22 44

100

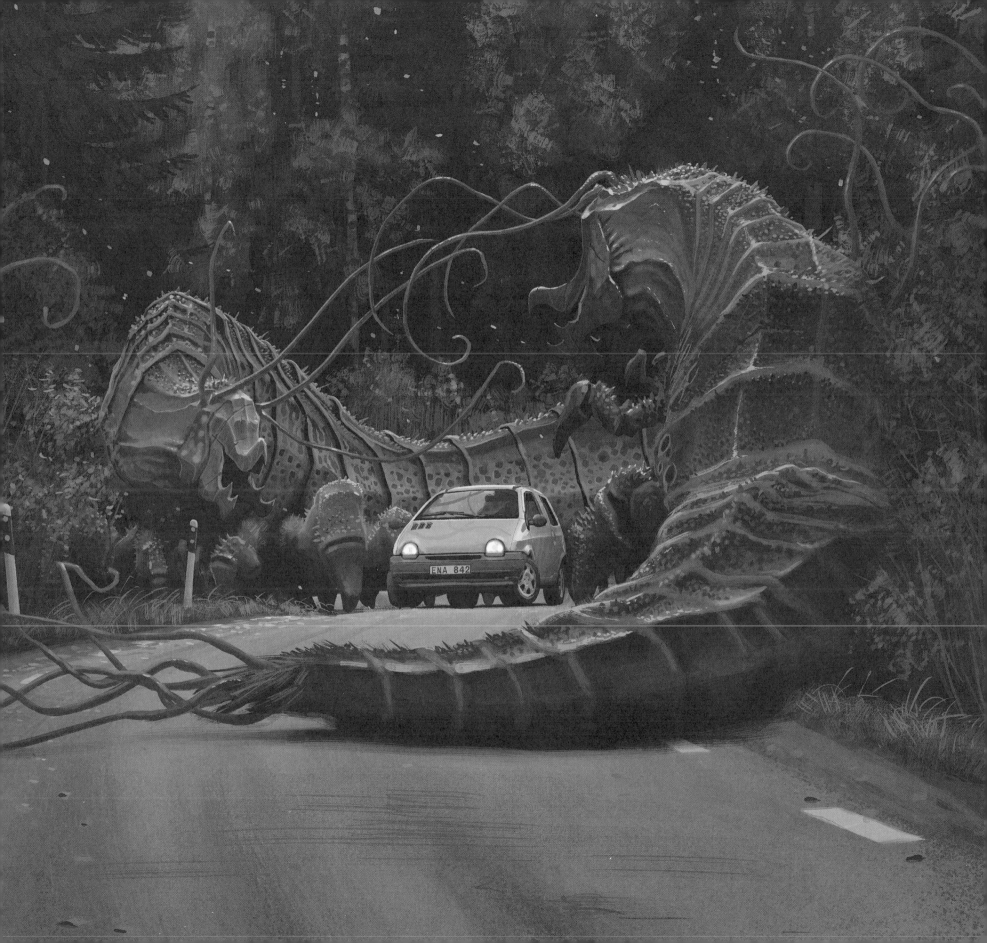

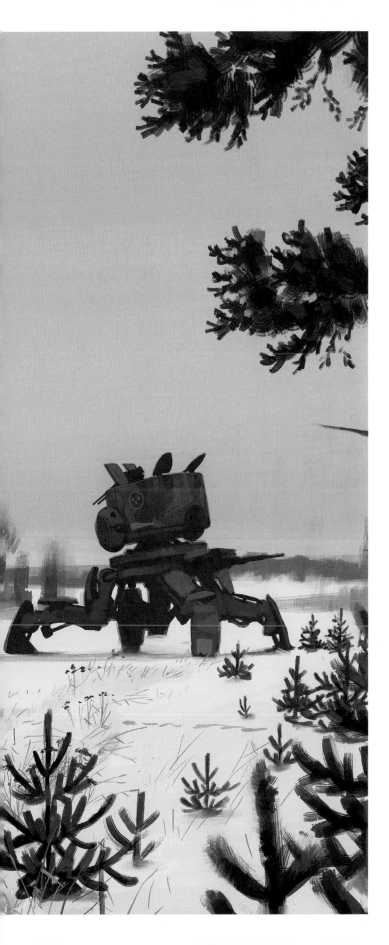

DEFENSE MECHANISMS

During the spring of 1997, the military arrived with their specialized machinery to assist Krafta with containing what was now known as "the Loop Scandal." The Gauss freighters over Färingsö were joined by several massive naval cruisers, and every gate and entrance ramp swarmed with trucks, cranes, and strange machines that we had never seen before.

You could see two AMAT-2 machines out in the field from the jogging path in the forest behind Sånga. During an outdoor recreation day at school shortly after Easter, Lo and I absconded from the sanctioned activities and made our way to the AMAT-2 machines. Up on the gun turret, Lo told me his parents were getting divorced and that he would be moving with his mother into the city after the summer. The worst part of it was that he said it like it was something positive, like he didn't even like Färingsö anymore. He did not seem to care that he was abandoning me in Berggården, so I said every bad thing that I could think of about life in the city, about how horrible it is to be a child of divorce, and about how he was really much better off out here on the island.

When that failed to elicit any reaction, I also threw in a bunch of nasty things about his mother and how he would probably be bullied by everybody at his new school because of his front teeth, and finally Lo sobbed a shrill cry. "BUT WHAT AM I SUPPOSED TO DO?!" Lo stared at something far away, and I think during that silence we decided to never speak about it ever again.

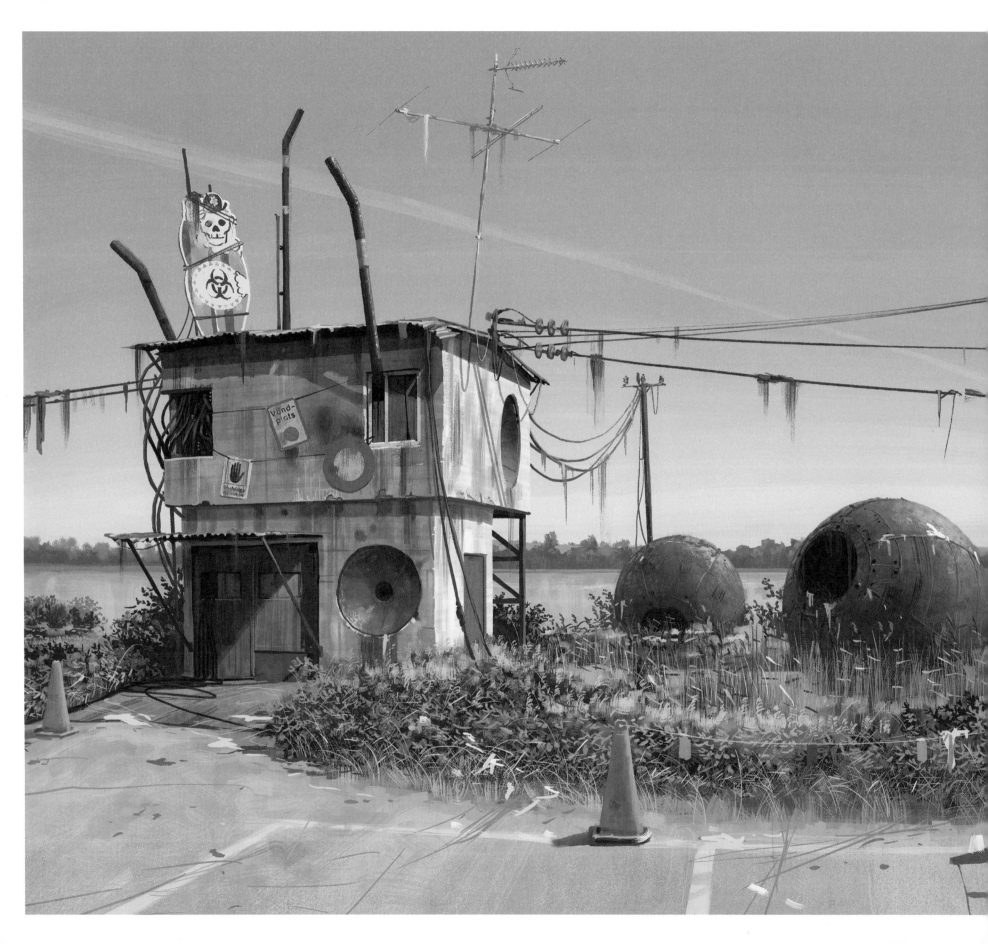

SURVIVING A PANDEMIC FROM 51 PEGASI B

It was Lo's mother who told us—when Lo and I objected angrily as she served tap water at the dinner table—that it was Stefan's brother, Håkan, who had worked at the Clovers facility. Stefan himself could never keep a job. "He's had a rough life."

And it got rougher still. One day when we went over to his house, his garden looked very neat and orderly, and an older woman claiming to be Stefan's mother opened the door. She said that Stefan had moved out; he had finally found his own place where he could keep all his things.

Stefan's own place turned out to be a small concrete shelter from the Loop era. He had barricaded himself in there, wearing a homemade protective suit. His body was wrapped in strips from what appeared to be a foam mat, and his head was covered by a gas mask and an orange hardhat. We recognized him by his voice.

"WHAT ARE YOU DOING?" he yelled through the window when he saw us walking up the almost completely overgrown path. He was not happy to see us. He continued yelling at us.

"THE CONTAGION IS AIRBORNE! STAY AWAY!"

ILLEGAL COPIES

"Particle-based teleportation has never worked and will never work."

Lo and I were seated on a worn couch in the Astronomer's basement. We were waiting for his latest toy, a 4xCD burner, to finish a cracked version of the latest operating system. Lo was hunched over his Gameboy, about to break his Tetris high score. Stefan continued his rant.

"They experimented with it in the early sixties and it went straight to hell every time. The problem was that they basically created an expensive photocopier. Whatever came out on the other end was only a copy, and it wasn't even fully coherent. You know, they ran tests on dogs and it was a damn mess. That's why they ended up pouring all their resources into relativistic technology. It's really bizarre that all that old equipment is still out on Rönn's field behind the power station in Björkvik. It's a goddamned miracle there hasn't been an accident yet."

We stood in the hallway, tying our shoes. Before Stefan handed us the disc, he opened the CD case, stuffed his nose down there, and took a deep breath.

"Aaaah! I love the smell of napalm in the morning. Make sure that Lars Ribbing doesn't see that, for God's sake."

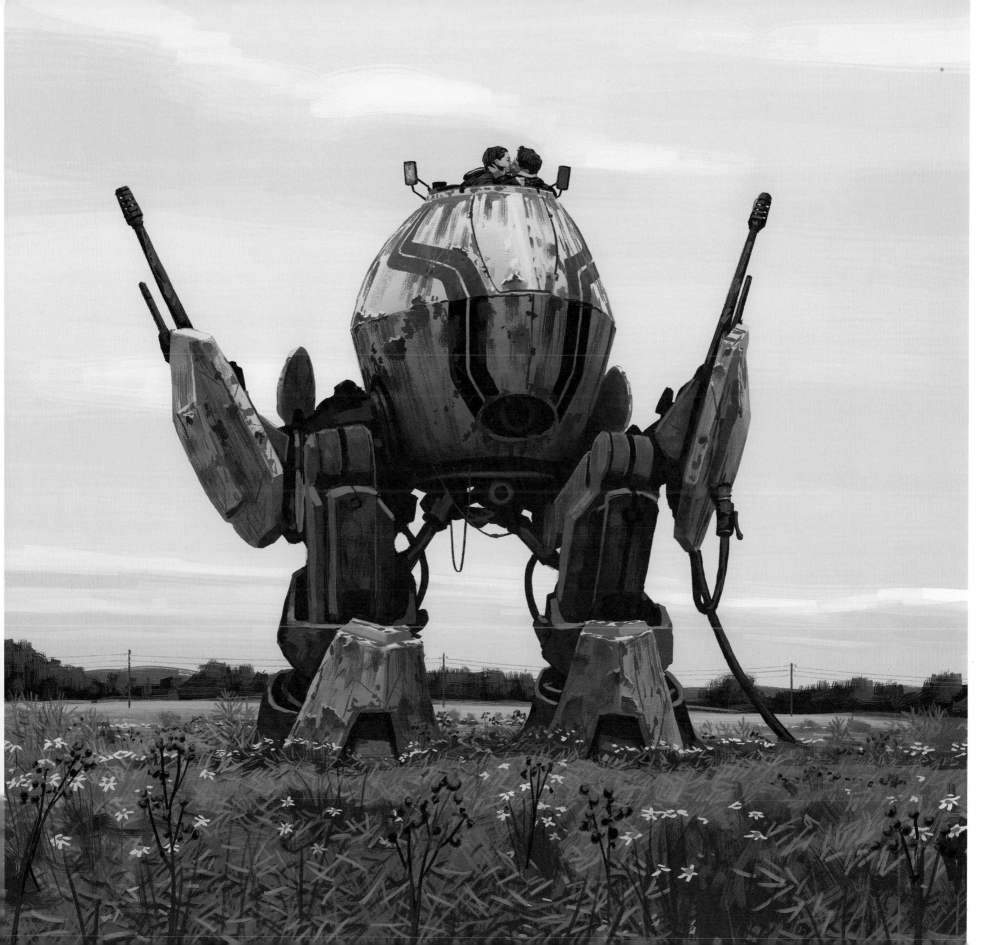

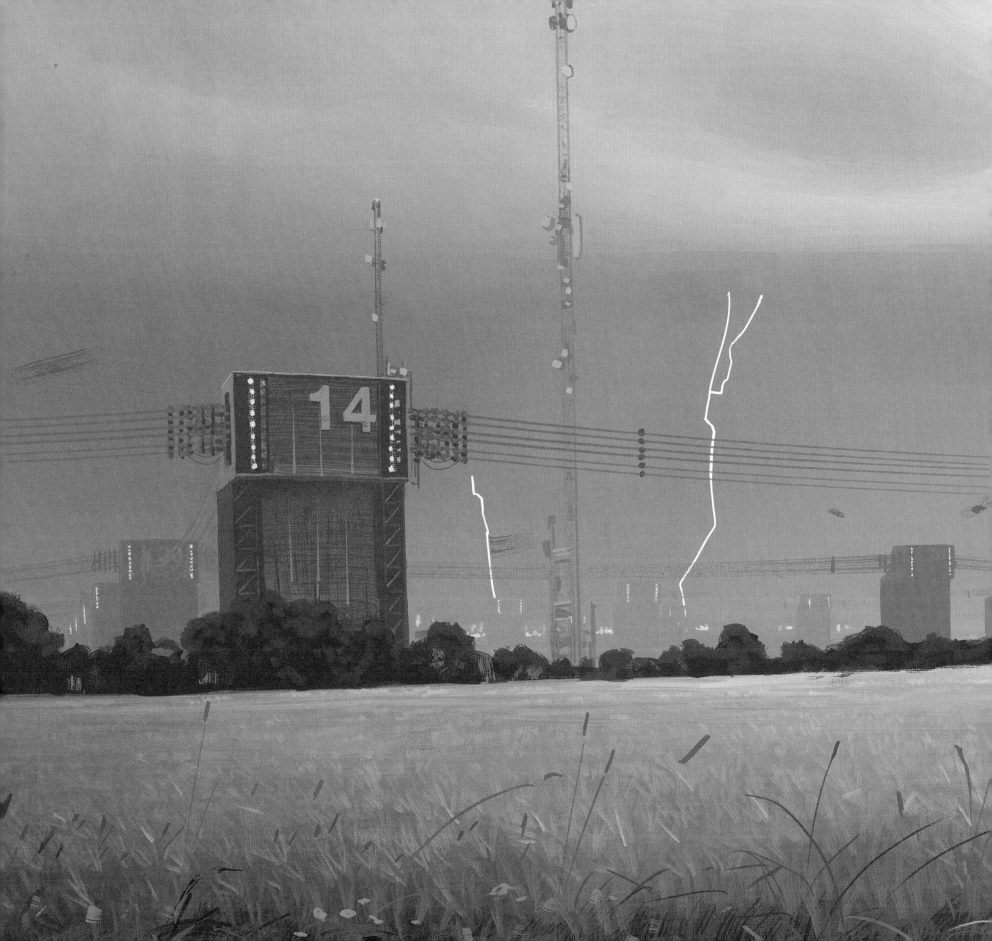

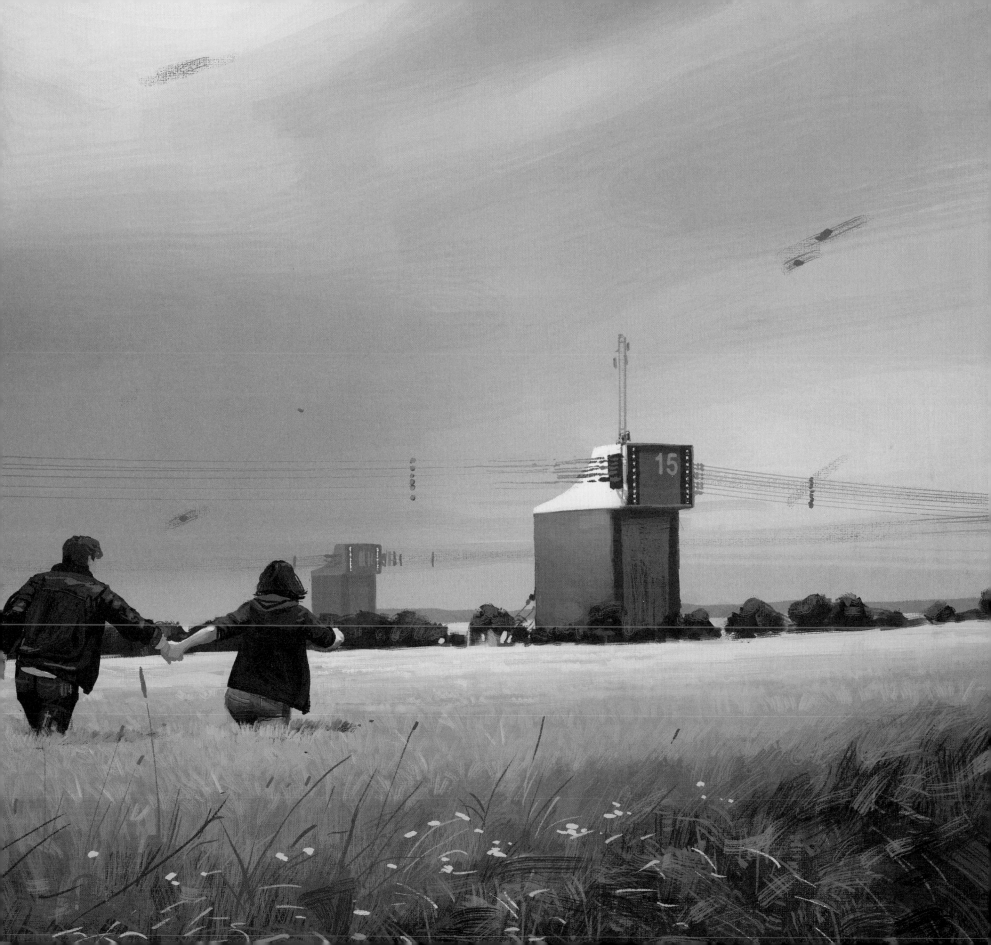

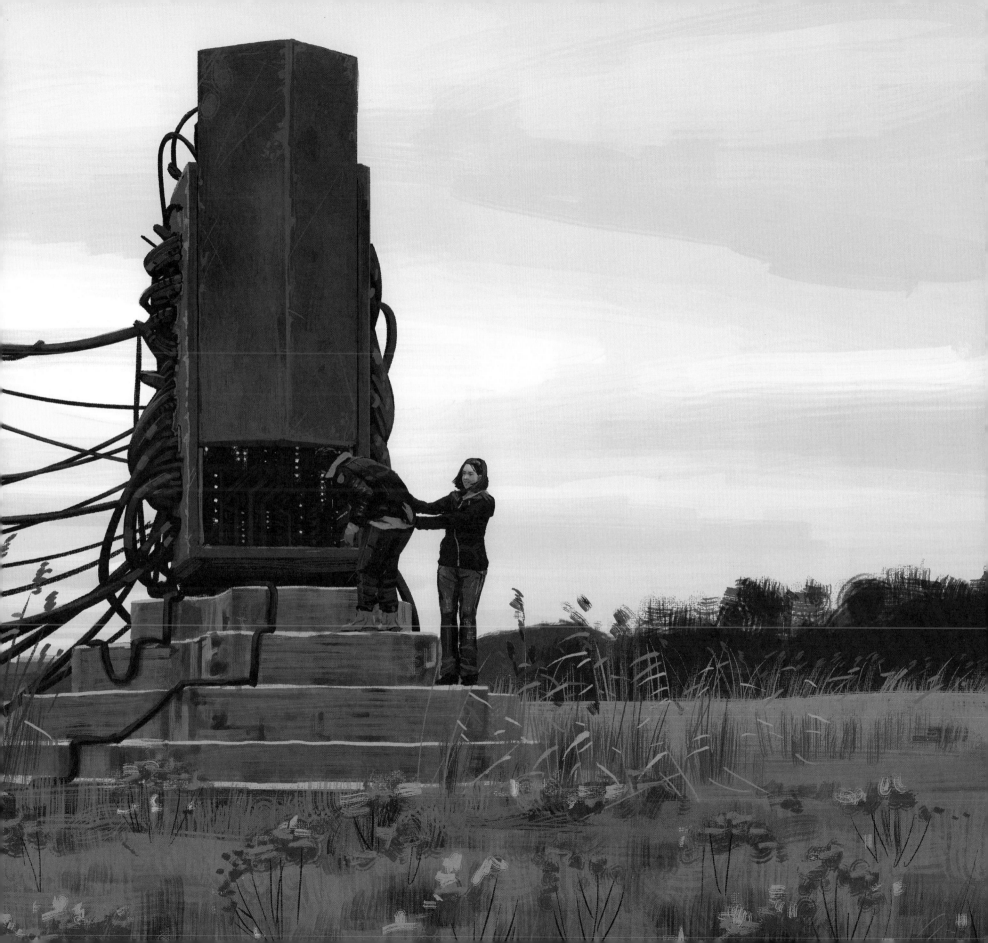

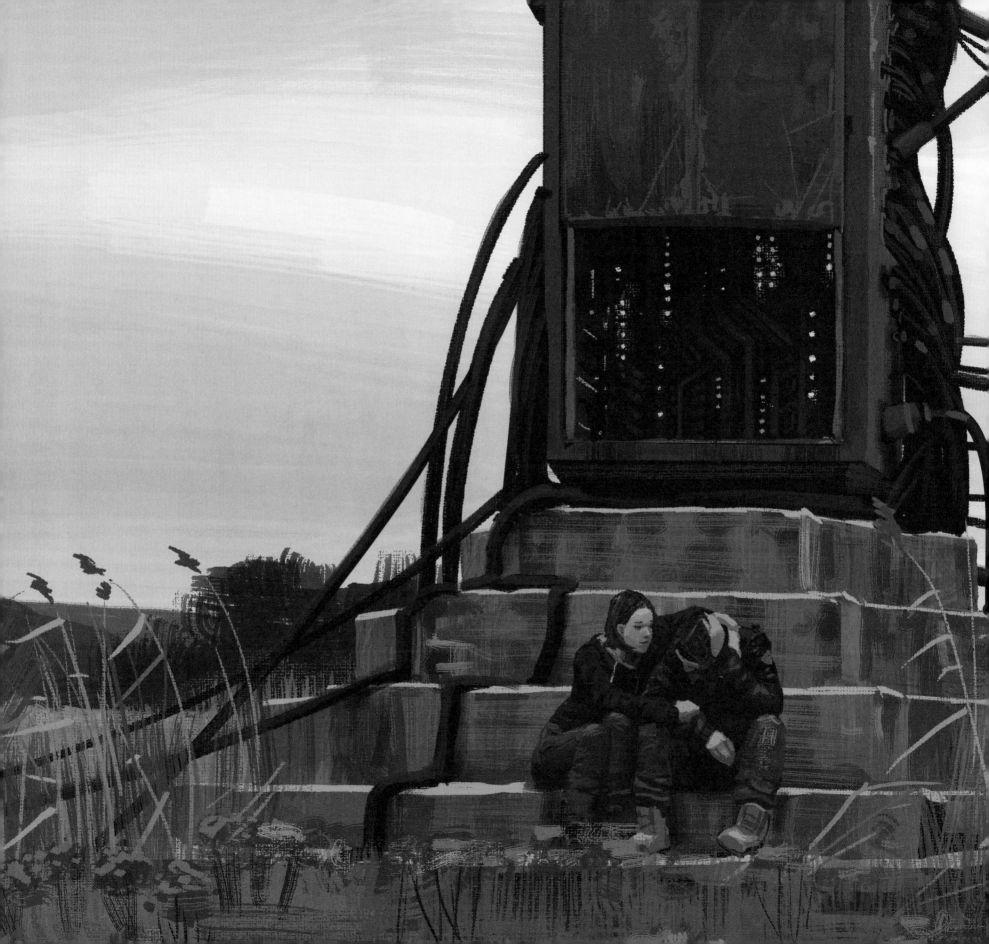

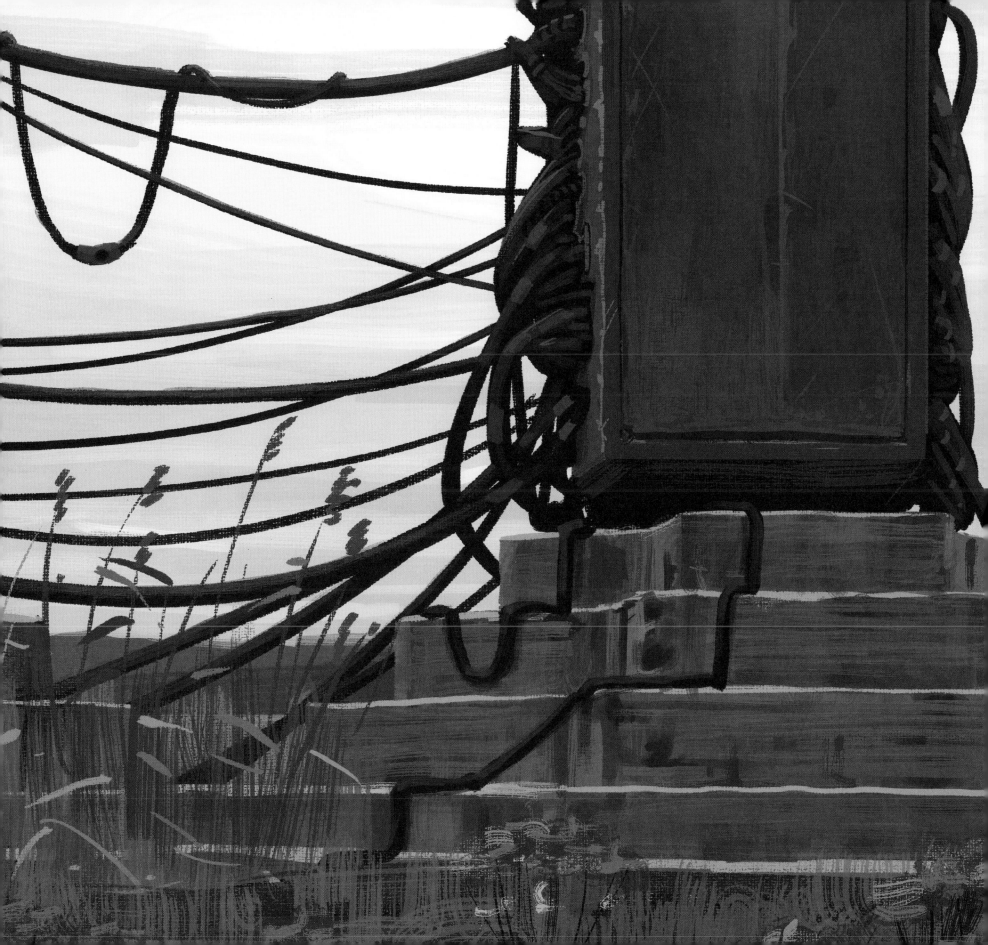

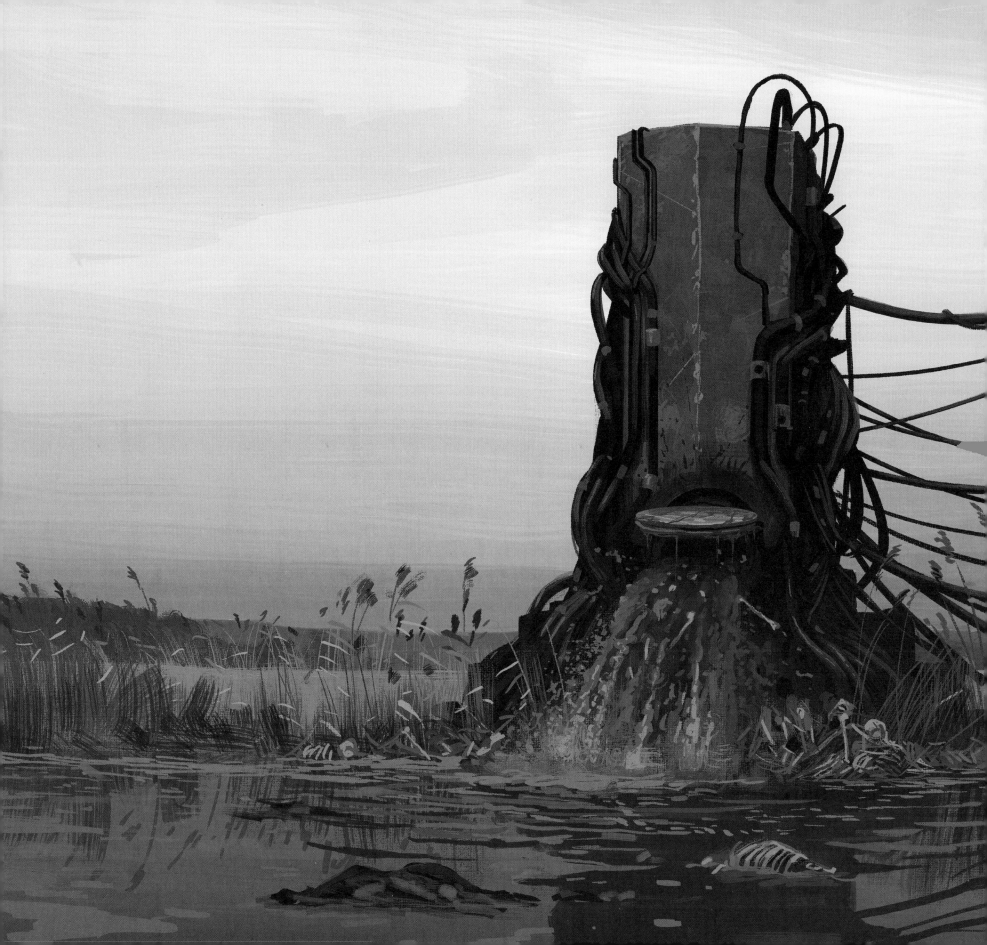

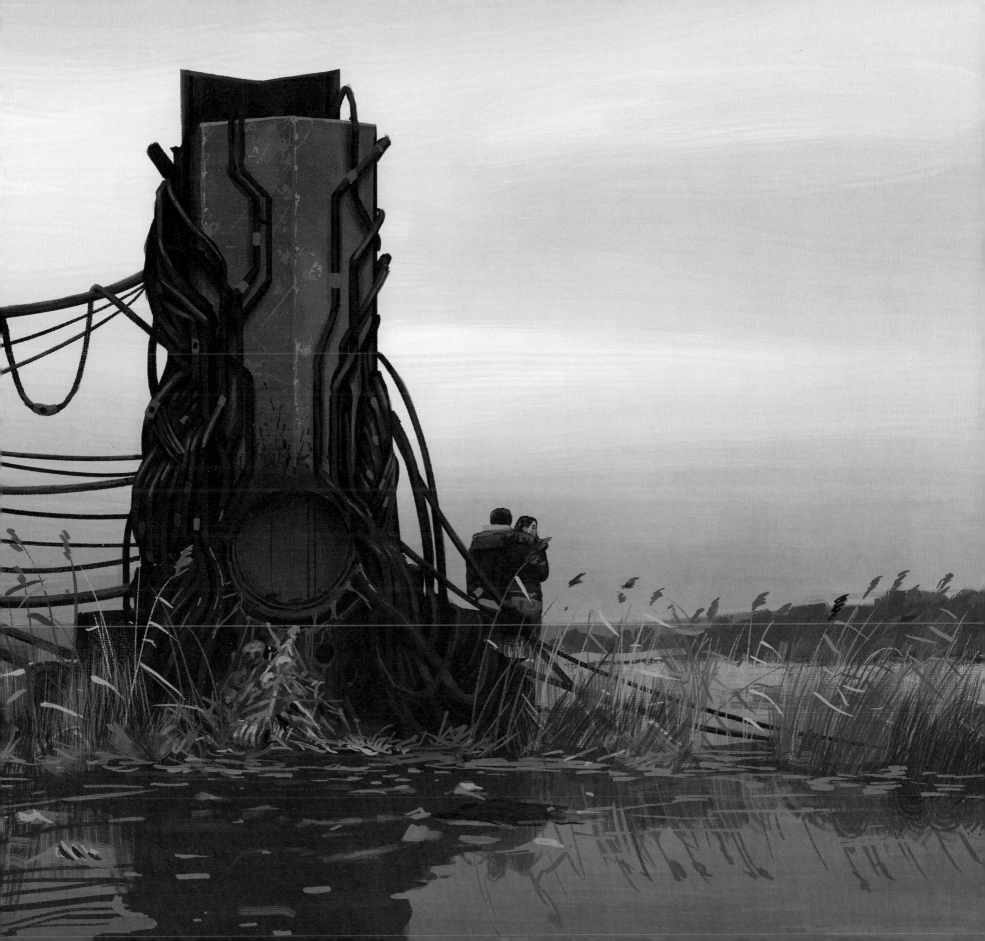

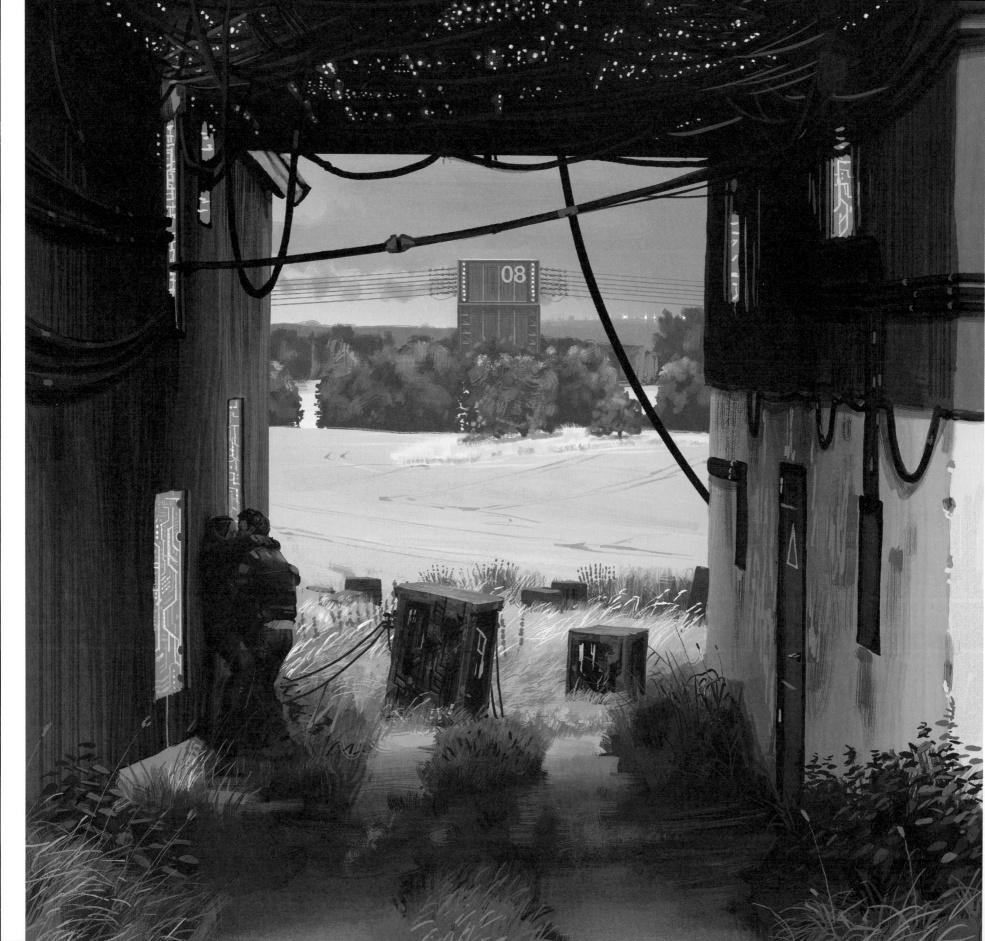

THE TIME OF BLOSSOMING

When Sebastian Fredriksson in 9A disappeared in the summer of 1997 and it was rumored that he had perished in one of the old machines down in Björkvik, the county had had enough. The islands were going to be properly cleaned up, along with what was now a tarnished reputation.

The bedrock would be cleansed, and all the old crap rusting in the landscape would be removed. Every single abandoned machine, every steel sphere and magnetrine disk, and even every single small rusty nail and sharp point that in any way posed a health hazard or cluttered the view, was doomed. Grandiose plans were drawn up and the entire shrimp-colored town hall in Hägerstalund seethed with fresh resolve. Golf courses, gyms, and sport centers would be built, and the stationery would get a new and fresh graphic profile, clearly signaling that a glorious new era lay before us.

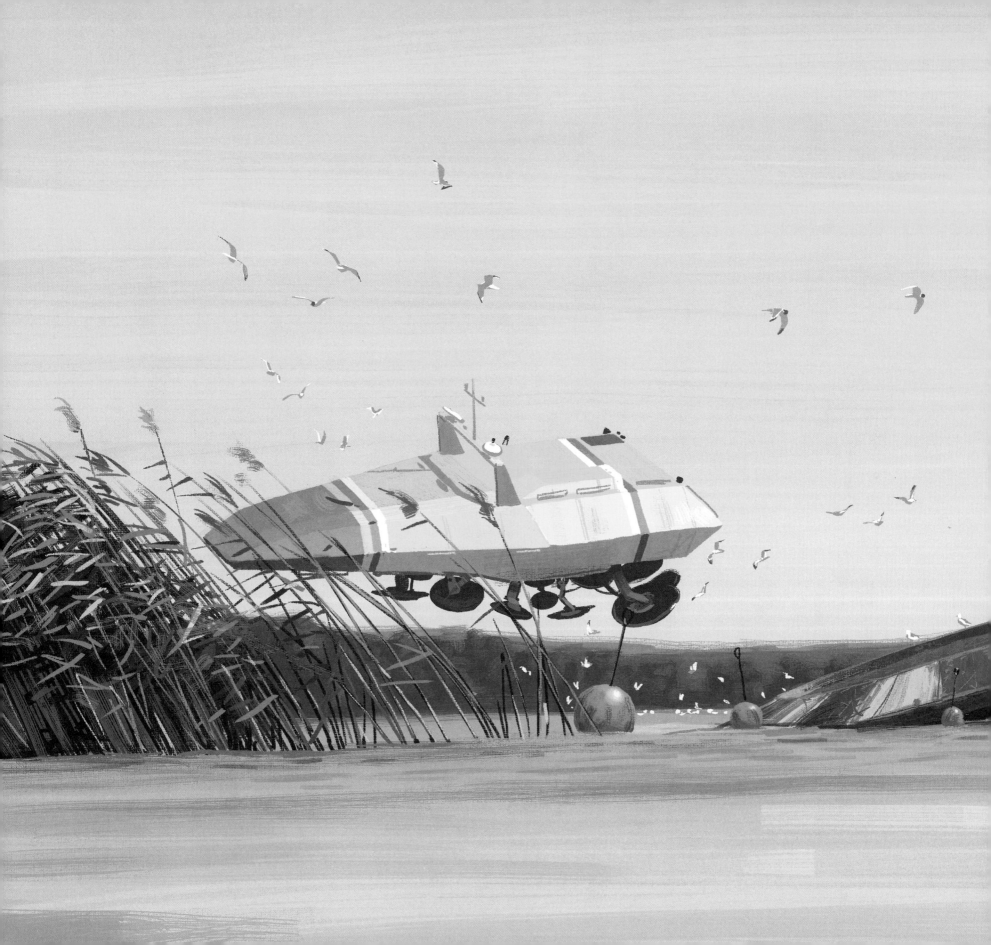

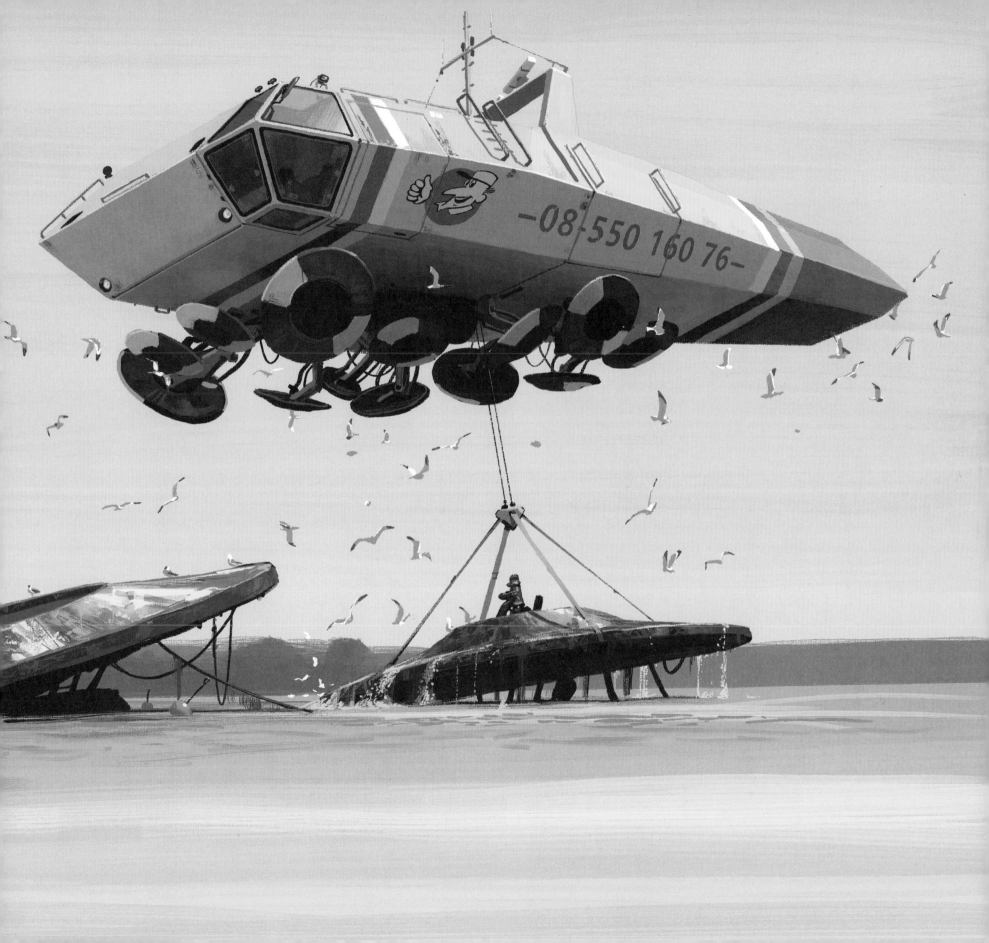

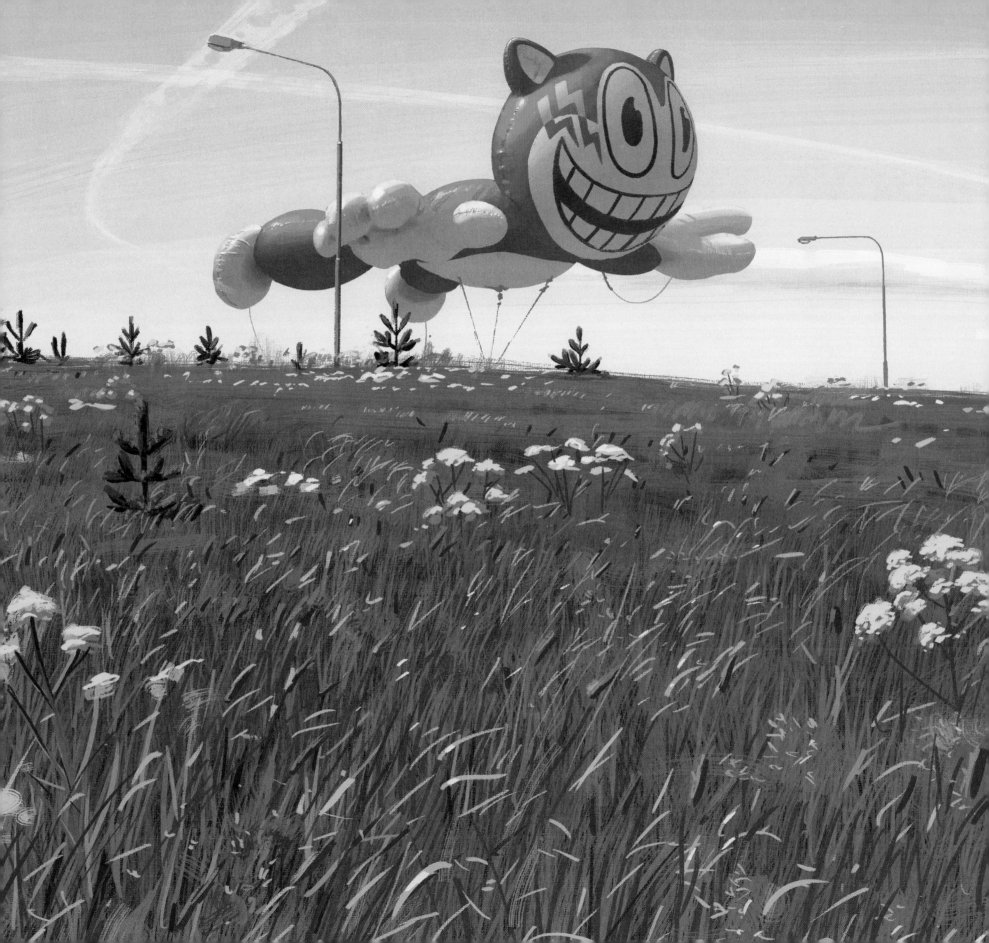

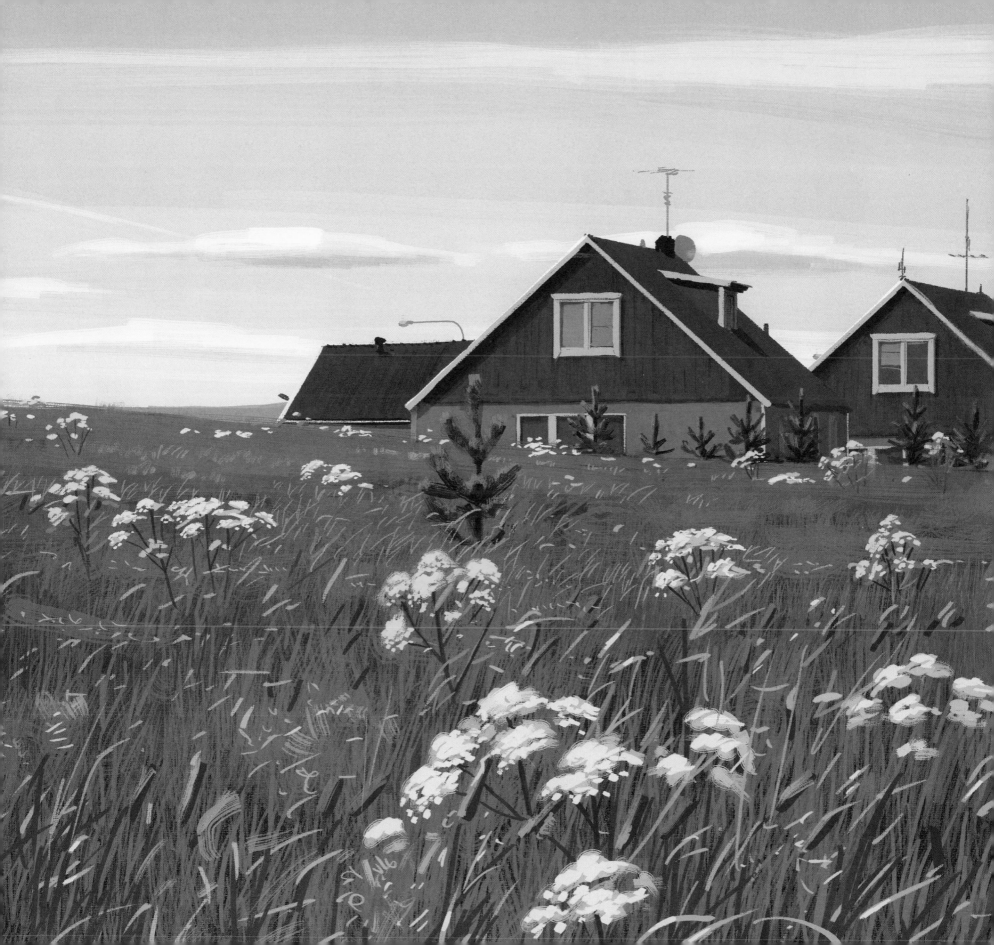

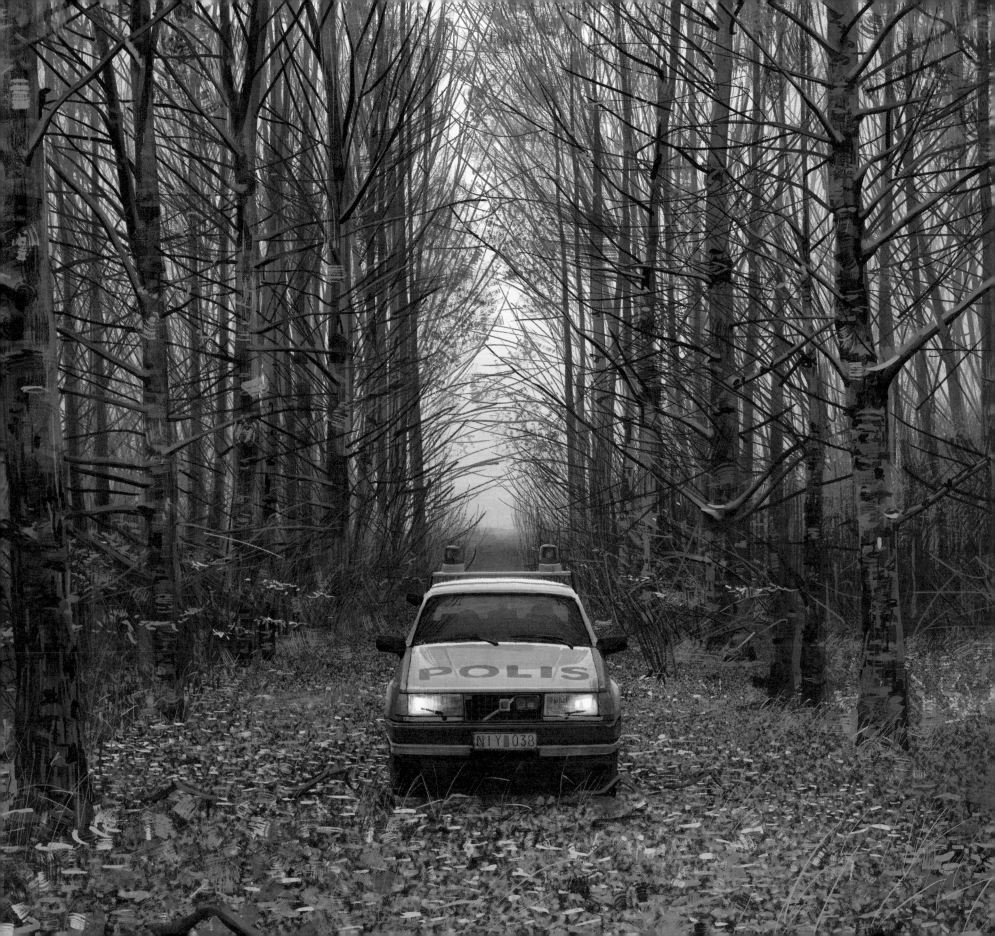

A FAREWELL OF SORTS

After what could have been a romantic getaway with Lars, my mother came home with a black eye, and it was immediately obvious that our stay under Officer Ribbing's roof was coming to an end.

The last time I saw Lars was when he picked me up after school in his police cruiser to have a conversation "man to man." He didn't really say much. Most of it was about things he had done that, according to him, I would somehow understand as I got older. He shook my hand before I stepped out of the car, as if we had made some sort of deal. That was the last time I saw him.

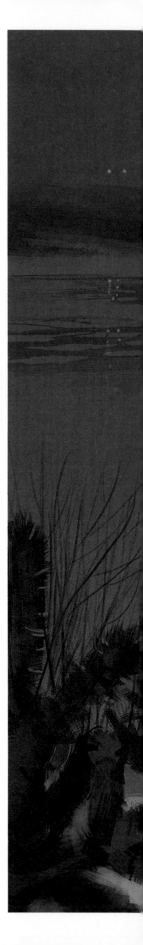

A GENERAL SENSE OF STYLE

Lo was gone when school started in the fall, and I thought school would be unbearable without him. But amid the excitement of starting junior high school, all the natural laws had been upset.

Just imagine the miracle of Jimmy Kraftling's unexpected onset of acne, and his amazing status descent from King of Middle School to Completely Anonymous Seventh Grader. It was as if the decontamination of the Loop had removed something from inside me, and had left me washed clean and smelling of aftershave.

Anyway, a few weeks later I had new friends who smoked cigarettes, and by Saint Lucy's Day I wore a leather jacket and had enjoyed my first drinking binge.

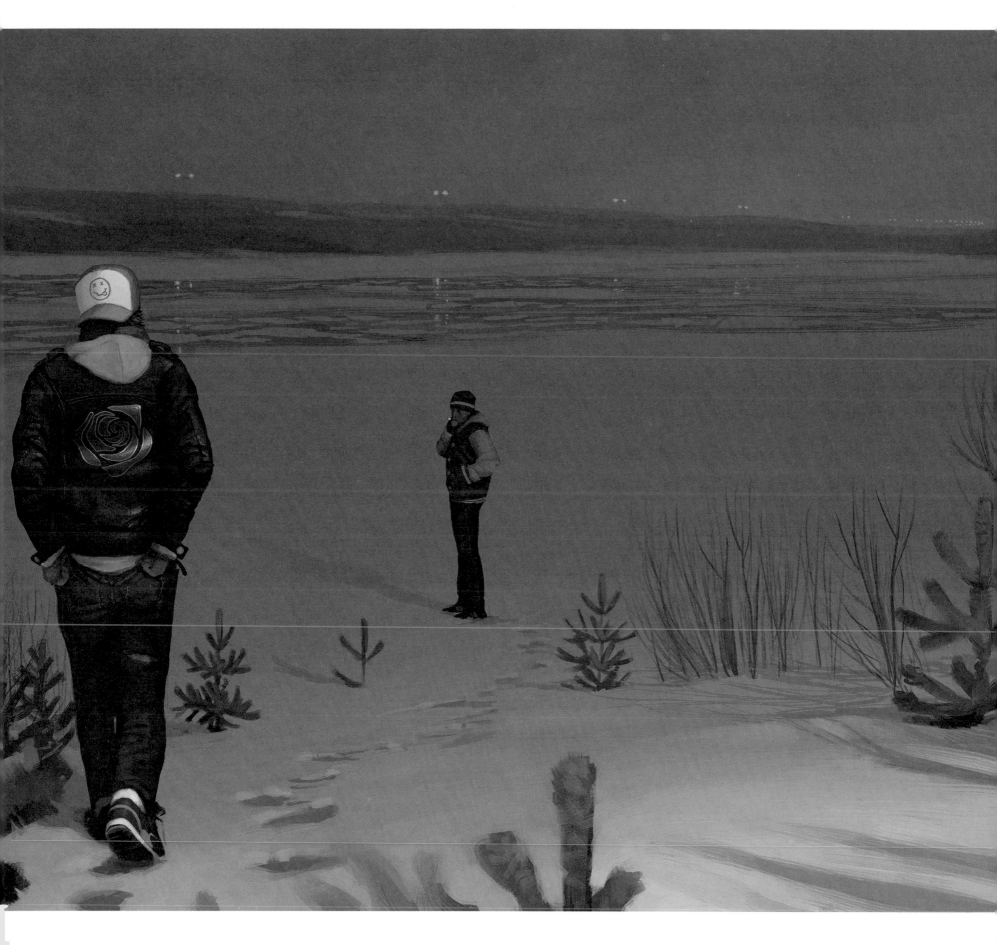

WELCOME TO YOUR
NEW INSTALLATION OF LIFE '98

Finally, in October of 1998, the decontamination project was over and the cordons were removed. Among fields and wooded slopes, the houses stood steaming in the cold autumn air, newly-washed and ready for their tenants to move back in. The former marshlands were dry, now torn up and hollowed out. Under the newly rolled-out lawns, the ground was covered by imported Dutch soil of the finest quality. The cooling towers had been demolished and ferried away, the telescopes at the observatory were neatly recycled, and in the depths of the bedrock the tunnels of the Loop were filled with 11,242,223 cubic meters of hardened carbon fiber–reinforced concrete—the result of what was probably the largest and costliest concrete cast in Swedish history.

The last traces of the Loop era were finally gone. As I stood in front of the mirror in my old room for the first time in three years, rubbing wax into my hair, I happened to glance out at the landscape outside the window and was struck by a brief sensation. It was a sense of something having been lost, but also a sense that I was already forgetting what it was. I shook the feeling off, turned up the volume on my stereo, and returned to more important things—in thirty minutes I was supposed to be at Martin Hagegård's party and my hair had to be just so.

Somewhere deep within the bedrock, where the nation kept its radioactive waste and where only machines labored, there were now endless rows of echo spheres filled with concrete. If we had been able to linger there without being incinerated by the radiation, and if we had been able to put our ear to the spheres, we might have heard it—the nervous heartbeats of something in there, slumbering restlessly.

ALSO BY SIMON STÅLENHAG

Tales from the Loop
The Electric State

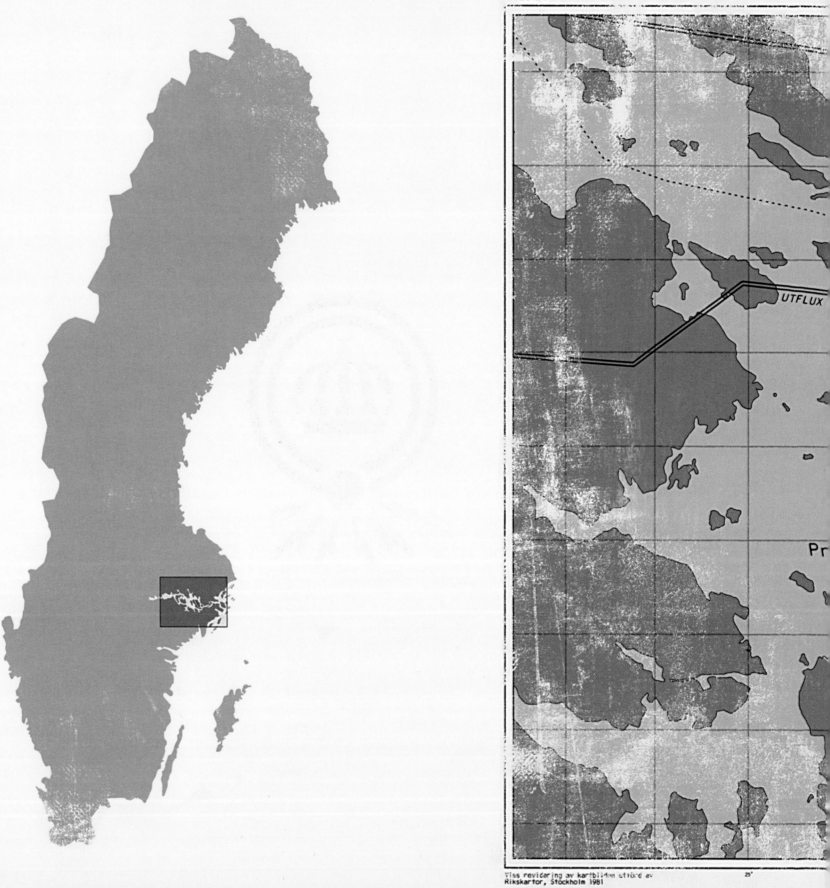

UTFLUX

Pr

Viss revidering av kartbilden utförd av
Rikskartor, Stockholm 1981

25'